PAINT RED HOT LANDSCAPES THAT SELL!

A sure-fire way to stop boring and start selling everything you paint in oils

by *MIKE SVOB*

international **artist**

international
artist

International Artist Publishing, Inc
2775 Old Highway 40
P.O. Box 1450
Verdi, Nevada 89439
Website: www.international-artist.com

Edited by Terri Dodd
Designed by Vincent Miller
Typeset by Ilse Holloway

ISBN 1-929834-18-7

Printed in Hong Kong
First printed in hardcover 2002
06 05 04 03 02 6 5 4 3 2 1

Distributed to the trade and art markets
in North America by:
North Light Books,
an imprint of F&W Publications, Inc
4700 East Galbraith Road
Cincinnati, OH 45236
(800) 289-0963

ACKNOWLEDGMENTS

I feel I owe a thank you to every artist who has ever given
me a useful tip on how to paint, or a pat on the back
when things go amiss. I feel very privileged to be part
of the continuum of artistic endeavor even if it be a
"wee small part".

I would also like to give Jeane Duffey a special mention
for not only prodding me to do this book but also for all
her selfless efforts in helping artists everywhere. A thank
you as well to my Publisher, Vincent Miller, and my Editor,
Terri Dodd for their patience with us creative types and
their own artistic input into this book.

Finally, to my son Elliot, my daughter Sienna and my
soulmate Nancy — this book is dedicated to you.

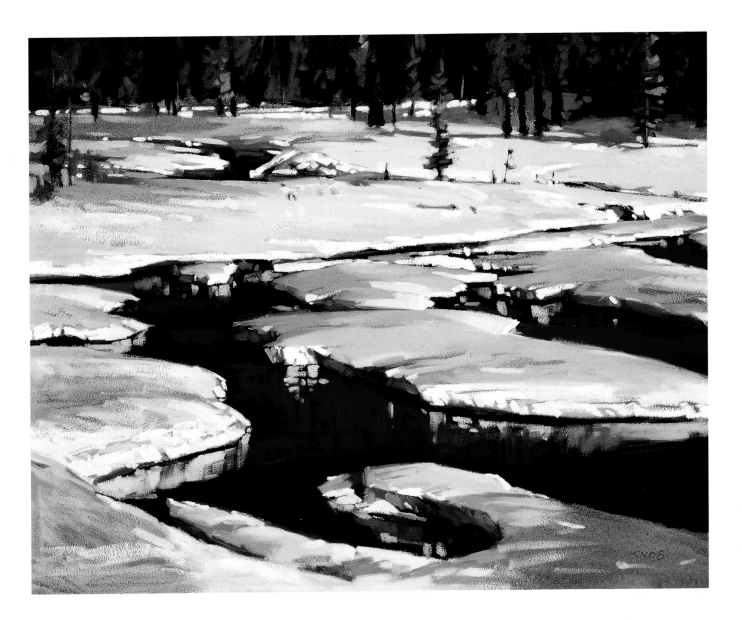

PREFACE

First, I must say that I am honored to have been asked to write this. I have known Mike Svob, and been witness to many of his accomplishments, for more than 20 years. There is nothing that he cannot paint. He will tackle anything from the 16 x 20" canvas that I proudly own to 300 foot murals.

Equally at home in oils, acrylics and watercolors he is a popular and much sought after instructor with a real commitment to helping other artists. His students share the full benefit of his knowledge — nothing is held back. Everyone is inspired and somewhat awed by his confident demonstrations, unique use of color and constant originality. The key to much of this is his complete mastery of drawing and design.

The proof of Mike's success is the number of artists who emulate his style. The sheer volume of work and its consistent excellence is amazing. I have seen countless slides of paintings long since sold and I envy his collectors.

Mike is blessed with a wife who is always there to help, contributing her own skills and knowledge of the graphics industry. Nancy fully understands the difficult path that an artist takes. The only thing neither of them has achieved is an ego.

This book reveals the mind, methods and skill, honed by time and commitment of an exceptionally talented artist.

— Jeane Duffey

Jeane Duffey is an artist and is the Canadian Editor of *International Artist* magazine

CONTENTS

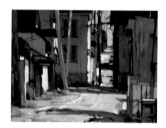

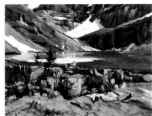
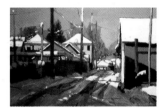

PAINTING BESTSELLERS

Triggering the buying response.

Today, all around the world, millions of people will doodle, scribble, draw and paint paintings. Tens of thousands of these people call themselves artists and they will try to sell their work by any means. Today, many thousands of paintings will find a new home.

If you want to be one of those professional artists who make a living selling their art it will require a great deal of self discipline and hard work. Talent is nice, but optional. If all you want from your artistic endeavors is to do your best work possible, that is half the battle and all the fun in becoming a successful artist.

The intent of this book is to help you find your own way in the medium of oil painting. It contains some different useful ideas both about the techniques and design possibilities available to the oil painter. I hope it will help guide you toward discovering how to create paintings that you yourself would be proud to own and show to others. If you are lucky enough to sell a few of these paintings, good on you. If you are very determined and disciplined you may even be able to make a career of it .

Remember, every time an artist sells a painting, their vision, inspiration and hard work has been validated by someone else. In the same transaction, that someone else has had their own vision, inspiration and of course "good taste" similarly reinforced.

Even if you have no intention of "selling your artistic soul" this book should help point you towards discovering where your painter's heart resides and how to keep it pumping.

Art is in the eye of the beholder

When artists put their brushes to work, they are setting out to create an illusion. Even artists who paint in what would be considered a realistic style are trying to deceive the viewer. They want the viewer to believe that what they painted was at the scene, and that if the viewer had been there too, that is what they would have seen.

In reality, a painting is only bits of colored pigment on a ground, but the viewer reads or abstracts whatever meaning they want from it. Each person perceives something different in a work of art. We all see the same thing but we read or conclude its meaning differently. It took me many years to understand that art is in the eye of the beholder.

What turns buyers on?

People will identify with your paintings for any number of reasons — some of which may have never occurred to you. For instance, I am told my forte, or what sets me apart from other artists, is my bold use of color. It is true that color can create an irresistible connection between the painting and the viewer. But, before I think about color, I resolve the tonal values, shapes and drawing.

I believe that what triggers the buying response in my collectors is my artistic expression — the way I use color to get my message across, the way I use color to emotionally draw the viewer in. The colors I use may not be what people would normally expect to see in real life. They are an unexpected interpretation that viewers are unlikely to ever experience for themselves. So while it may be color that makes my work such red hot bestsellers, it is the way I arrive at the color that is my secret — and that is what I am going to share with you in this book.

Ultimately, the artist is trying to make an emotional and/or intellectual connection with the viewer — and that is the reason for painting.

MAKING SALES

Let's try to be honest here about selling paintings. Anyone who wants to pursue art as a career needs to sell their work. There are many ways to do this. Any one of the following methods, or combination of methods, may work for you.

- ## Commercial fine art galleries and dealers

These dealers will want to make money either by purchasing the paintings outright and reselling them or, as is more usual, by selling the work on consignment.

For well-established artists commercial galleries are the simplest, most efficient way to sell. However, the gallery door tends to open slowly to the beginning or aspiring artist.

- ## Regional circuit art shows

Most countries have art shows, both indoors and out, where large numbers of artists can display and sell their own work. And they may even win a cash prize or award as well. For the personable artist the art show is a great way to turn some of those paintings that are clogging up the studio into cash.

This method of selling has the advantage of giving you the opportunity to meet the people who buy your work, face to face. You will be amazed at their comments as they explain how personal your painting is to them.

- ## Commissions from corporations or publications

This is another common way to sell your services as an artist. The problem, or advantage, depending on how you look at it, is that the buyer will want to dictate the look or the subject matter to some degree. The nice side of commissions is that you know the work will be paid for. Because it is a tailor-made work of art, you may even charge a premium for it.

Whatever selling methods work for you, I recommend you believe and practice the following:

Keep the artist who paints the paintings completely separate from the artist who sells the paintings.

If you fall into the trap of going out to sample or check on what artwork has sold, and then rush back to the studio to paint similar works, you will be forever chasing your artistic tail. Artists, by definition and personality, should be creative types who set the trends. Trust your inner judgment and believe that doing it your way is the right way. Once your inner artist has nurtured and created the painting, the job of finding the right home for your creation is an entirely separate occupation.

So let's see how to go about painting a red hot landscape that sells!

FINDING YOUR WAY IN ART

Learn to understand yourself, then translate that feeling into your art and you will speak to your buyers.

The most valued treasures of civilization are works of art. The queue to view some of the better known paintings by Leonardo Da Vinci, Claude Monet, Vincent Van Gogh and others is never ending.

Millions of people from all the cultures of the world find something intriguing in works of art. Why? What can make some ground-up dirt on canvas or a hand carved lump of stone so important? The answer is a simple one:

People find emotional inspiration in works of art. People come to love certain works of art because **the work speaks to them**.

A painting needs to say something to someone to be of value. For others to find inspiration and emotion in your painting you must put it there in the first place. To be an effective artist you must first learn to understand yourself.

In many ways, artists are like scientists — they are both seekers of some kind of truth. The artist's truth is found in understanding and expressing their personal emotion and inspiration in abstract, graphic form. The scientist seeks truth in abstract concepts and theories about things outside emotion and inspiration.

To effectively create paintings that speak to you and ultimately to others, you must ask yourself questions about what you really connect with in graphic, artistic language.

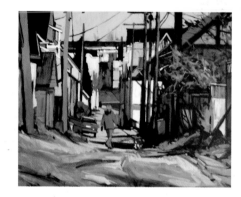

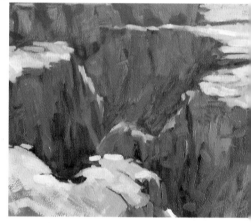

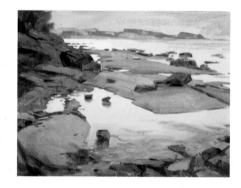

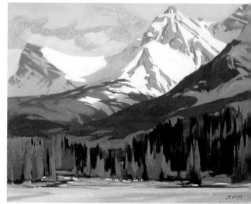

AND SALES

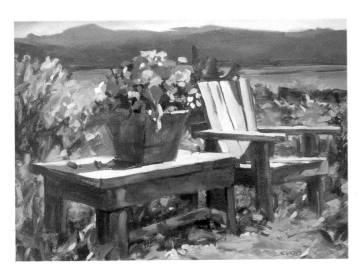
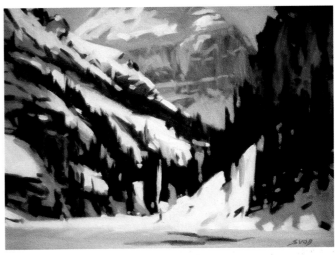
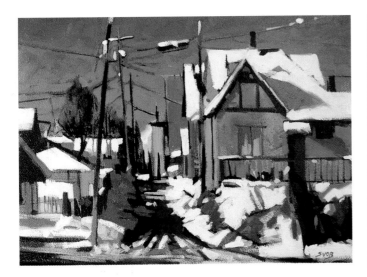
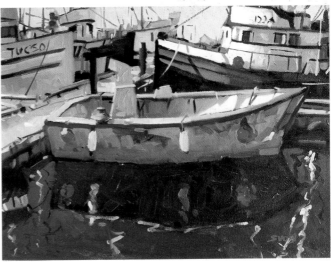

You must learn to trust your own feelings, judgment and analysis about what you like in a painting, and why. Ambivalence in your approach to a painting will lead to an ambivalent response from the viewer.

EXERCISE

Developing your personal vision

What do I like about this painting?

Is it the subject matter, the style, the sense of reality or abstraction that grabs my eye?

Is it the color, the shapes, the brushwork, the lighting or another graphic element I find intriguing?

Could it be the way the painting is presented, its scale, or even the framing that adds to the visual pleasure?

Please don't say it is because the painting goes with the sofa. Leave that judgment to those who do not paint. Painting is to many people and in different ways, merely decoration. I just like to think of it as something more, even if it is just a tiny bit more.

The questions you will need to explore as an artist are very often similar to the questions that potential buyers of a painting ask themselves. **The artist or the buyer will connect with a painting because it fulfills some emotional need.**

The differences between the way an artist and potential purchaser understand and appreciate a single painting are not important as long as both parties derive something from the exercise.

The striving artist is always dealing with the critical question of like or dislike. Ambivalence is not an answer. The questions you ask or the answers you come up with in regards to the matter of painting are critical to the development of your artistic painting skills.

For others to find inspiration and emotion in your painting you must put it there in the first place.

> **You must learn to trust your own feelings, judgment and analysis about what you like in a painting and why.**

Ambivalence in your approach to painting will lead to an ambivalent response from the viewer.

All artists, be they amateur or professional, are adding to and building onto the body of work in the visual arts. Whether you want to become a so-called professional artist who sells their work, or a hobby artist looking for a distraction or something relaxing to do on a holiday, painting can be and should be its own reward. There are many silly notions about being an artist that have nothing to do with the creative act of applying paint to a surface. I know many frustrated people who call themselves artists who spend all their efforts on anything but improving their painting skills. Beware of this trap. If you like art and painting it will give you a lifetime of enjoyment, surprise and satisfaction. All it asks is that you seek your personal inspiration and practice your graphic language (painting) skills.

What is it that makes one landscape painting more appealing than the next?

The answer is not always obvious or consistent from one person to the next. The exact reason an individual may fall in love with a painting, perhaps it's the color in a landscape painting, can be the very reason the next individual hates it.

The saving grace for the artist trying to sell his or her particular work of art is that **it only requires one person to like it enough to buy it**. In many conversations with artists and others it has become apparent to me that many people mistakenly believe that by somehow appealing to the broadest, lowest common denominator audience they will please more people, derive more satisfaction and ultimately sell more work. In the end, I think this approach will only frustrate the artist and eventually bore the audience.

If some characteristic of a subject appeals to you make sure you drive that message home in the painting. The more elegantly and simply stated your message the more positive will be the response.

How To Be Clear About Your Personal Vision

The more painting you expose yourself to the clearer your personal vision of what your own artwork should look like becomes. Studying the work of other artists will help you learn to discriminate in order to develop your own taste, and will open up your eyes and soul to the range of possibilities in painting, both historical and contemporary.

TURNING VIEWERS INTO BUYERS
What made these paintings bestsellers?

Nancy's Walk,
24 x 30" (61 x 76cm), oil on canvas

This is a painting of two of my favorite people: my wife Nancy, and Jasper, our miniature schnauzer, who have appeared in many of my paintings.

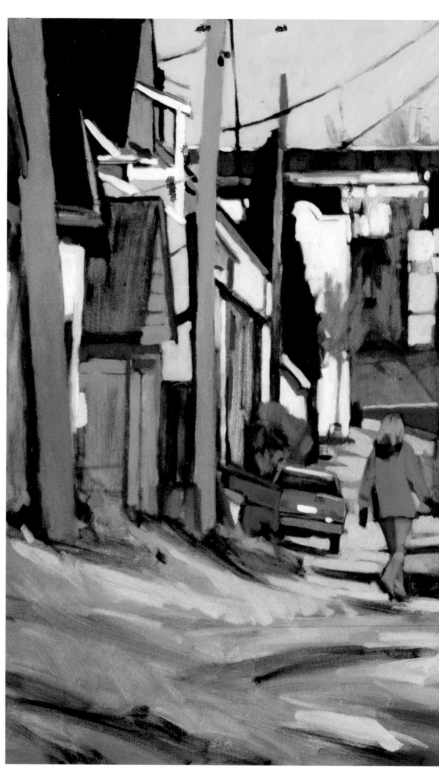

DESIGN PLAN

VERTICAL AND HORIZONTAL SHAPES
The vertical shapes created by the utility poles play well with the more horizontal, rectangular shapes of the buildings.

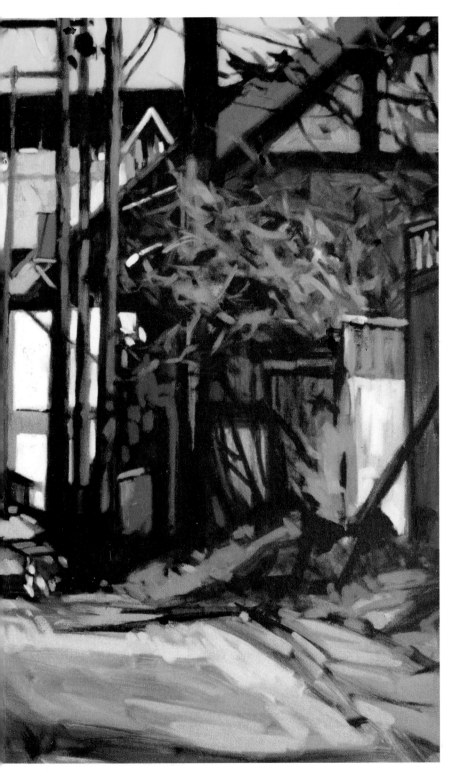

Check your emotional response to this painting

What do I like about this painting?

How does this painting speak to me?

What ideas can I use in my own work?

How would I do it differently?

See what happens when I remove the figures

The figure walking the dog creates the focal point. When a small figure is introduced into a large landscape it gives the scene a friendlier feel. Without the figure there are too many areas of strong contrast, with no one area being dominant over the others.

DESIGN PLAN
COLOR

The tidal area presents ever-changing patterns and shapes with which to work.

The color scheme is mostly invented, except for the rich green on the flat rock area. A combination of Viridian Green and Cadmium Yellow was used for the green. The rocks are covered with an intensely green algae that just had to be captured in this painting.

The procedure I followed was similar to how a watercolor might be done. The paint was applied wet-in-wet, and almost all areas are quite transparent. The only opaque passages are the cool blue areas on the water and the middle distance rocks.

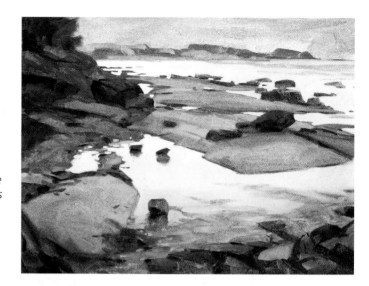

DESIGN PLAN
EDGES

Edges are the make or break part of any professional painting. Using edges effectively gives you more nuances and control of the viewer's eyepath. From the softest, slowest transition from one color or tonal shape to the hardest, razor sharp edge, painting edges is something you should be aware of and practice.

DESIGN PLAN
PERSPECTIVE

Used elegantly in a painting, perspective can invite the viewer straight into the scene to the focal point — the message — in your work. Perspective also gives depth and aerial perspective to the scene. Perspective aids the illusion of three dimensions on a two-dimensional surface, and it's use should never be overlooked.

Late In The Day, 18 x 24" (46 x 61cm), oil on canvas
The Gulf Islands off the Coast of British Columbia were the setting for this painting.

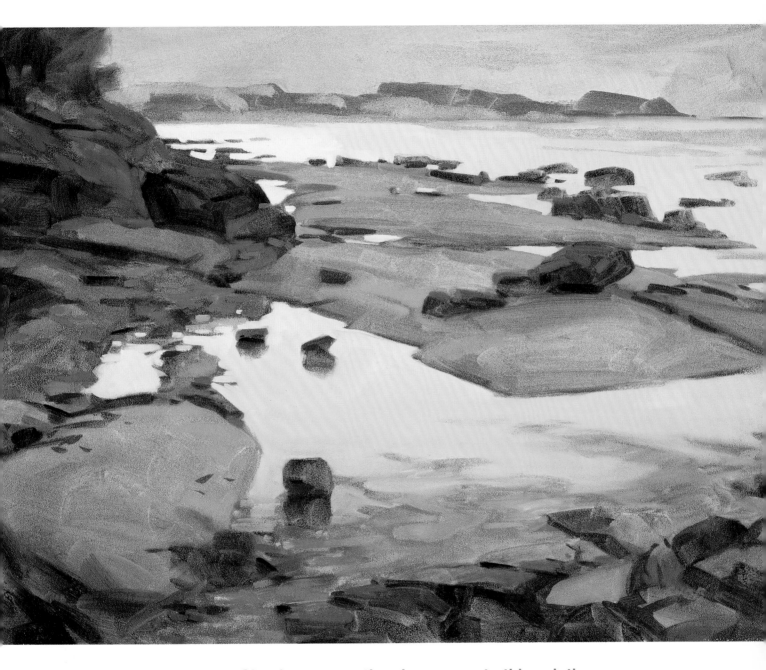

Check your emotional response to this painting

What do I like about this painting?

How does this painting speak to me?

What ideas can I use in my own work?

How would I do it differently?

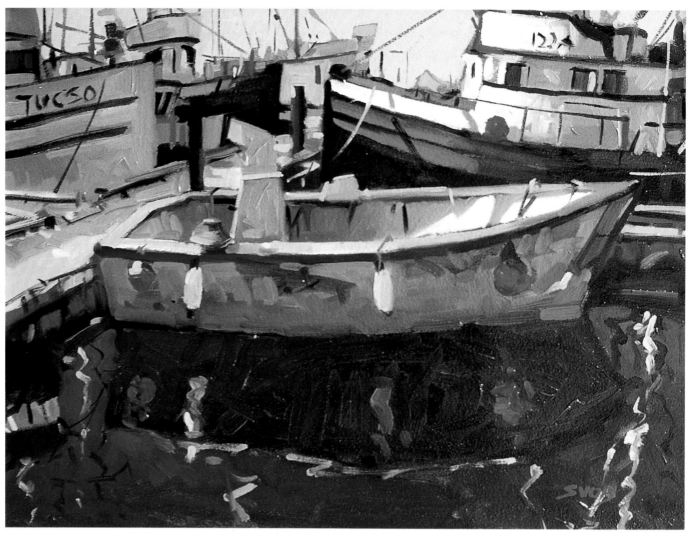

Dock Dance, 12 x 16" (31 x 41cm), oil on panel

Check your emotional response to this painting

What do I like about this painting?

How does this painting speak to me?

What ideas can I use in my own work?

How would I do it differently?

DESIGN PLAN

REPETITION

The repetitive pattern of shapes receding into the distance made me want to paint this scene. Before I commit paint to canvas, I try to convince myself I understand what a painting will be about. In this case it was the shapes of the boats rhythmically rocking back and forth that formed the basis of this painting.

I began on a board toned with Transparent Earth Brown. The cooler blues were painted opaquely over the top. The darker values were kept warmer and transparent.

DESIGN PLAN

COLOR TEMPERATURE

The smaller side canyons off the south side of the Grand Canyon caught my eye when I was flying over the area. They are made up of vibrantly warm colored rock. No cool colors anywhere. The challenge here was introducing enough cool color to make the reds, oranges, and ochres appear even brighter in hue. I used Ultramarine Blue in the deep area of the foreground, and Cobalt Blue in the distance, to give the feeling of atmosphere.

Check your emotional response to this painting

What do I like about this painting?

How does this painting speak to me?

What ideas can I use in my own work?

How would I do it differently?

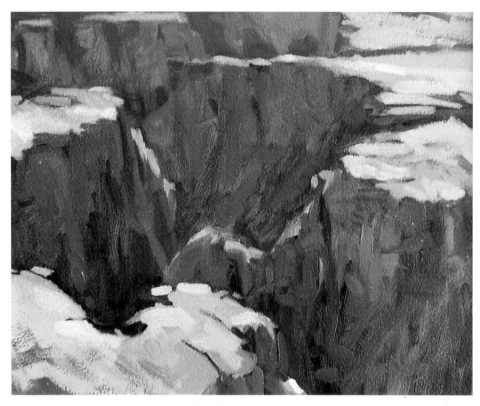

Canyon Vista, 8 x 11" (20 x 28cm), oil on panel

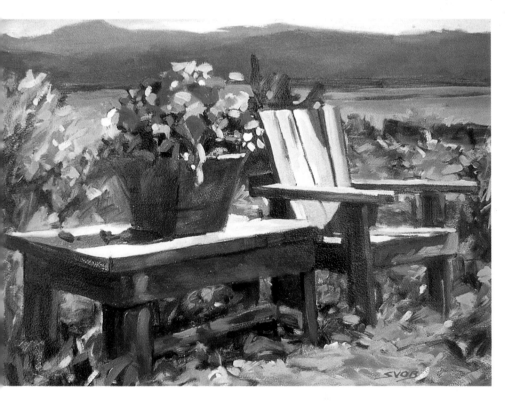

Island Serenity,
12 x 16" (31 x 41cm), oil on panel
On the west coast of North America we have two seasons: wet and dry. The painting here represents the dry season on the Gulf of Georgia at Qualicum Beach, Vancouver Island.

The ever-present mountains and ocean provide a cool blue backdrop for this warm, inviting place. The lighting is cool, as it often is in this part of the world. The shadow area on the table and chair are much warmer than the areas in the direct sunlight.

The color and lighting are basically the way I saw them at the time, which is an unusual situation for me because I usually alter the scene in some way.

Check your emotional response to this painting

What do I like about this painting?

How does this painting speak to me?

What ideas can I use in my own work?

How would I do it differently?

Sun and Snow,
12 x 16" (31 x 41cm), oil on panel
*You will see numerous street and alley
scenes appearing on these pages because
they have become a favorite subject of mine
in recent years. This painting was begun as
a demonstration for a sketch club, which is
somewhat similar to working on location.
The demonstrator has about an hour or so
to educate and entertain the group. Any
longer and you risk being drowned out by
the chatter or, God forbid, the snoring.*

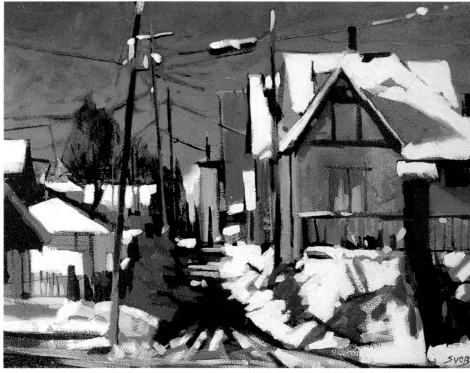

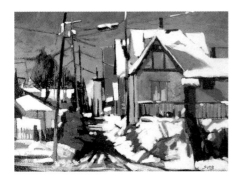

DESIGN PLAN
TONAL VALUES
*This mono version will help you see the tonal value plan of darks,
grays and lights. Take note of the pole on the left, which bisects
the painting. The lower portion is mid-tone against a dark then
it changes to dark against a mid-tone sky. This graphic device is
useful because it keeps such long, thin shapes from bisecting the
painting into separate shapes.*

Check your emotional response to this painting

What do I like about this painting?

How does this painting speak to me?

What ideas can I use in my own work?

How would I do it differently?

Sunshine at Louise,
12 x 16" (31 x 41cm), oil on panel
*Lake Louise is an alpine jewel in Banff
National Park in the Canadian Rockies. It is
undoubtedly the most spectacular alpine
lake in the world. I have been spending time
here virtually every year since I was sixteen
years old. It never ceases to recapture my
sense of awe and wonderment at the
natural world.*

Check your emotional response to this painting

What do I like about this painting?

How does this painting speak to me?

What ideas can I use in my own work?

How would I do it differently?

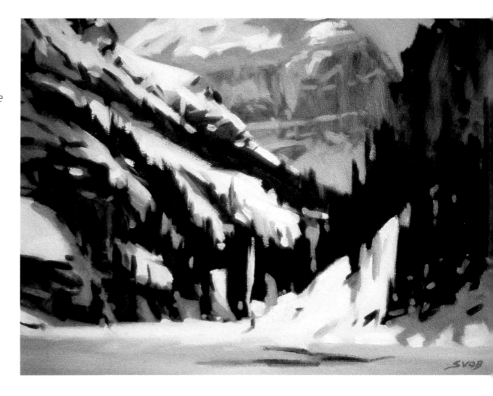

20

Alpine Reflections,
18 x 24" (46 x 61cm), oil on canvas
The snow has mostly melted off Bow Lake exposing a crusty icy surface that will melt and refreeze for weeks until finally disappearing in May. The higher elevations are still under a heavy blanket of snow and appear much lighter in value than the lake.

DESIGN PLAN

SHAPES

Overlapping shapes in the trees and then the mountains helps to provide a sense of depth and distance to this painting.

Check your emotional response to this painting

What do I like about this painting?

How does this painting speak to me?

What ideas can I use in my own work?

How would I do it differently?

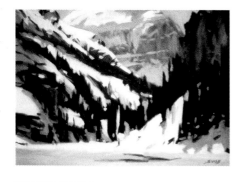

DESIGN PLAN

LIGHT

The lake pictured here is frozen and snow-covered, just as it is for a good part of the year. The light when the sun reflects off the snow is absolutely brilliant. To try and capture the brilliance the trees have been rendered in very dark values. A sense of warmth is achieved by the use of warm reflected light on the rocks and a warm sky.

. . . many people mistakenly believe that by somehow appealing to the broadest, lowest common denominator audience they will please more people, derive more satisfaction and ultimately sell more work.

GETTING YOUR MESSAGE ACROSS

Maximize the painterly qualities of transparency, opacity and texture because these also attract buyers.

Before we go any deeper into producing paintings that speak to buyers, I would like to give you a few practical words of advice about the materials professional artists should use, and why.

The materials artists use to create works are a compromise between permanence, ease or suitability of use and their cost.

Longevity versus cost

Paintings should last for **a reasonable length of time** in excellent condition in the exhibition setting or environment for which they were intended. This should be an important consideration to the artist. However, artists are divided on the issue.

At one extreme are the artists who believe that future generations can create their own paintings, and these people proceed with little consideration as to the longevity or permanence of their own work. At the other extreme are the artists who believe their paintings deserve immortality and should last for hundreds of generations. Deciding where you fall in this debate will help determine your choice of materials, medium and techniques.

The other factor that determines the choice of artist materials is cost. In general, **the more expensive the paint, supports, mediums, brushes, and so on, the longer they will last in normal use.** There is no up-to-date reference that is completely accurate as to what happens when certain materials are used in a certain manner and the end result exposed to certain conditions. This is because artists' materials and practice are always changing. In short, nothing is certain about permanence over a set length of time until that time has passed.

The compromise that works best for most artists is to **use current, common, best professional practice.** This is what I try to follow. If it is found in 20 or 100 years that even though I used materials that were in general use at the time my paintings still deteriorated, then it will give future artists more space to hang their paintings. (For more information about painting materials see "The Artist's Illustrated Encyclopedia" By Phil Metzger, or the painter's bible, "The Artists Handbook of Materials and Techniques", by Ralph Mayer.)

Working practice

Any discussions of artists' material should include some **commonsense** advice about proper care in **handling and usage** As a rule, even though all the reputable manufacturers pay strict attention to standards, all paints, mediums and solvents should be considered hazardous to human health and handled with care.

Keep all paints, mediums and solvents out of your mouth, off your skin and out of your lungs as much as is practical.

Do not eat or drink while painting or where you normally paint. Wear gloves and/or wash your hands religiously to keep paint off your skin. Finally, paint under well-ventilated conditions, especially when you are using the more volatile mediums and solvents.

In my studio I have installed very good **ventilation** with an overhead exhaust that exchanges the air in the room frequently. The foregoing discussion about permanence or safety has no impact on the immediate look of your paintings but it needs to be carefully considered by the practicing painter.

Sheer transparency, beautiful opacity and texture

The **properties** of the materials that will have an immediate impact on the look of your paintings, and the **procedures** used to create them, are crucial to your creative endeavors.

The properties of the paint that most concern my oil painting technique are as follows.

Transparency is a consideration when you are trying to alter a color without making a complete tonal value or color change. All oil paint pigments can be rated on a scale from transparent to opaque. This information can be found on the color charts and on the tube labels.

Painting Mediums

WITH MATERIALS AND GROUNDS

If you are not sure, you can use the following method to judge which of your pigments are most transparent.

To determine transparency, simply apply a thin glaze of the pigment over black. If the value or tone becomes lighter, the pigment is more opaque. If the color changes but there is no discernible change in value, the pigment is more transparent.

To some degree, all pigments are more transparent when used in thinner applications.

Thick applications of even the most transparent pigments will yield opaque results.

The fat over lean principle

The painting technique I use most often is to proceed from thinner, more transparent glazes through to more opaque, thicker applications to finish off. For the opaque, thicker passages it is important that the paint is stiff and has a heavy consistency.

To speed drying and to alter the paint's consistency or body I use alkyd in combination with odorless mineral spirits and, on occasion, a few drops of drying medium. (I use Cobalt Medium, but I use this very sparingly, since a very little goes a long way.) Alkyd is a modified vegetable oil that dries faster than linseed oil and has the added advantage of providing a varnish-like quality that prevents the color from going flat and deepens the values. Alkyd mimics what a retouch varnish does, or what a fresh coat of linseed oil does. Another reason I use drying medium is to speed things up when I am painting on location, or if I am cramped for time.

The technique I use — combining alkyd, mineral spirits and, occasionally, drying medium — works well for my painting personality.

It allows greater freedom to speed up, or slow down the drying properties of oil, and allows for more immediate results in a finished, varnished look. You will gather that I am not the patient type when it comes to working with the materials or in their application.

I would like to add that using alkyd and/or drying medium and/or mineral spirits does not change the important fat over lean rule about oil paint application. The bottom, or underneath, layers of paint still need to be drier or dry more quickly than each subsequent layer of paint. The practice of fat over lean refers to the amount of oil and pigment in each layer of paint. A word of caution — if you do not follow this practice your paintings will crack more readily.

Painting surfaces

The supports (painting surfaces) I most commonly use are as follows.

Rigid support

A medium density fiberboard, or MDF as it is more commonly known.

I prepare rigid supports by rough sanding prior to applying a chalk based acrylic gesso. I like the tooth provided by applying the unthinned chalk gesso with a rough painting roller. Two coats give a good, white, permanent ground on which to paint.

Lightweight support

I use a birch or mahogany doorskin for a thin, lightweight, smaller size rigid support when weight is a consideration.

General purpose

Canvas and linen with varying degrees of texture or weave round out the list of supports. These can be purchased pre-gessoed.

Toned Panels

Supports
Oak Doorskin Veneer
Panel prepared with Black Gesso
Panel prepared with White Gesso
Medium Density Fiberboard or MDF

PREPARING A TEXTURED GROUND

Preparing A Ground

The molding paste is applied with the palette knife. The more paste the more texture that can be achieved. When preparing my panels I like to leave the tooth of the gesso showing through in some places. Board, or another ridged support, should be used for this practice because of the resulting build up of weight.

Creating a unique surface

When wet, the surface can be manipulated with brush (as shown), scratched, stamped (embossed), or by using a myriad of other techniques altered to your satisfaction. When it is dry it can be carved into. The marble dust in the acrylic gel exposes sufficient tooth that enables the oil paint to adhere to the surface.

The surface texture of many oil paintings is often a source of mystery, especially to those trying to understand how it was created.

The brushstroke texture may be going in several directions at once. The paint may look like thick impasto, yet the surface has a transparent look. Quite often, the texture of a painting's surface appears to be part of the painting process when in fact the texture is a result of the ground.

Artists use numerous methods to prepare a ground, depending on the look they want to achieve. To prepare the painting surface (or ground) in this demonstration the following materials were used.

- *A medium density fiberboard (MDF) that had two coats of gesso applied over a rough sanded surface.*

- *A molding paste that was basically made up of thick acrylic gel and marble dust.*

- *A palette knife and a house painter's brush were used to apply and manipulate the molding paste on the gessoed board.*

THE PAINTERLY QUALITIES THAT TURN BUYERS ON

What made these paintings bestsellers?

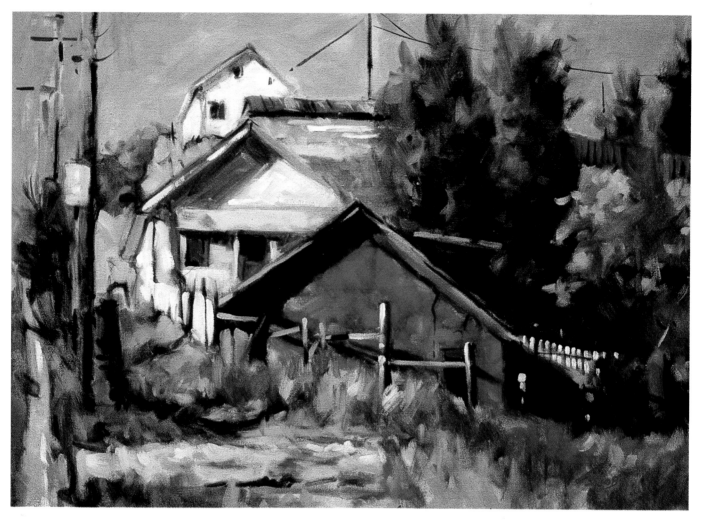

Montana Hillside, 18 x 24" (46 x 61cm), oil on canvas
Oil paint allows a great deal of time to deal with edges in a painting. The slow drying nature of oil provides a new area of exploration for the artist used to working in quicker drying or drawing mediums. This work has numerous areas where the paint was blended with a brush or wiped back with a rag to soften shapes.

SUPPORT PLAN

The entire canvas was toned with an earth color before I laid in the darker values of the trees and buildings.
So that the top paint layer would not blend with the underpainting, the lighter values were applied when the underpainting was dry.

What do you think buyers like about this painting?

What does this painting say to them?

What is it about the quality of the paint itself that is so attractive?

What is it about the texture of this painting that is so attractive?

What is it about the brushstrokes that is so attractive?

Can you see places where the ground shows through the layers?

What made these paintings bestsellers?

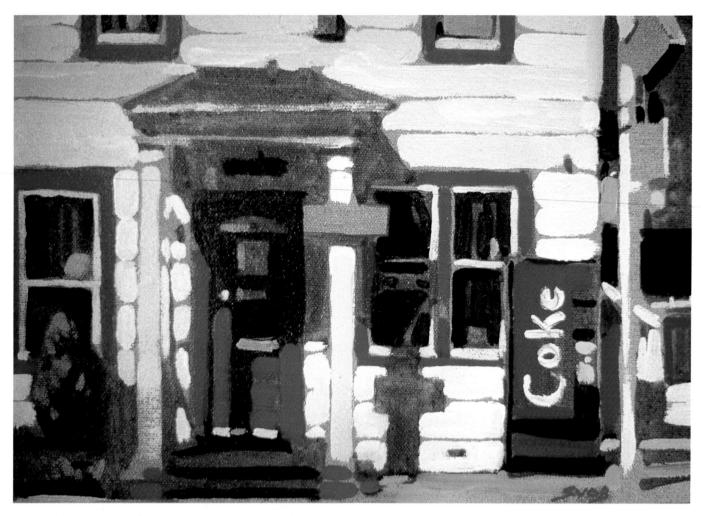

Lytton Hotel, 9 x 12" (23 x 31cm), oil on panel
This is one of my early attempts at using a very limited palette in oil on a toned canvas. The painting has a theme, and was harmonized by rectangular shapes of various dimensions, and by very warm color.

SUPPORT PLAN

*Burnt Sienna was used to tone the canvas and then **I was careful to allow it to show through wherever it seemed appropriate**.*

The transparent dark and darks mid-tones were brushed in first. The opaque Cadmium Reds and Titanium Whites were then painted over the transparent underpainting when it had sufficiently dried.

What do you think buyers like about this painting?

What does this painting say to them?

What is it about the quality of the paint itself that is so attractive?

What is it about the texture of this painting that is so attractive?

What is it about the brushstrokes that is so attractive?

Can you see places where the ground shows through the layers?

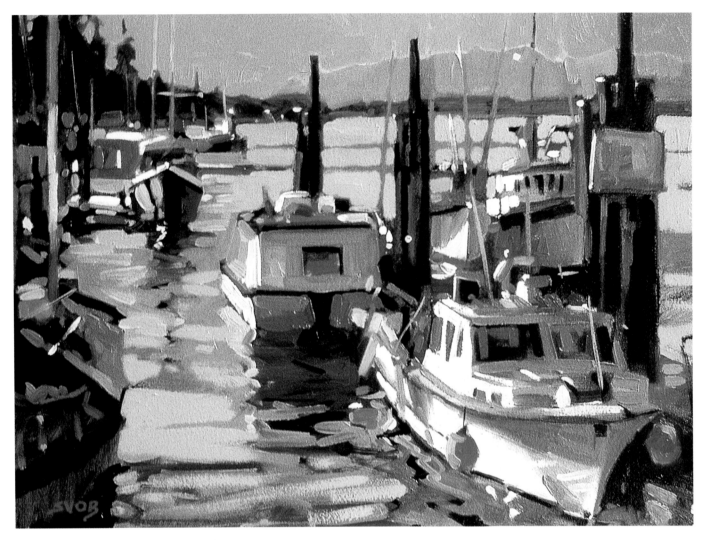

Fraser Boats, 12 x 16" (31 x 41cm), oil on panel
Small fishing boats are common in our area as they are in many other coastal communities. They are great shapes to work with wherever they are found.

SUPPORT PLAN

*I began brushing the transparent dark shapes directly onto a white gessoed panel. The build-up of paint is more noticeable as is the brushwork in the opaque passages. **A characteristic of gesso applied with a roller is the rougher tooth that results.** The rough tooth holds the thicker brushwork better than a smoother textured surface.*

What do you think buyers like about this painting?

What does this painting say to them?

What is it about the quality of the paint itself that is so attractive?

What is it about the texture of this painting that is so attractive?

What is it about the brushstrokes that is so attractive?

Can you see places where the ground shows through the layers?

White Rock Hillside, 9 x 12" (23 x 31cm), oil on panel

This captures the flavor of the area in which I live. The peninsula is several hundred feet above the ocean and there are beaches at the base of the bluff. There is limited access to the beaches, but you can see them from many high vantage points, as in this painting.

SUPPORT PLAN

*The painting was done on a panel prepared with gesso then toned with Burnt Sienna. Although the painting is mostly cool shapes **I allowed some of the Sienna color to show around the edges to give it a warmer feel***

What do you think buyers like about this painting?

What does this painting say to them?

What is it about the quality of the paint itself that is so attractive?

What is it about the texture of this painting that is so attractive?

What is it about the brushstrokes that is so attractive?

Can you see places where the ground shows through the layers?

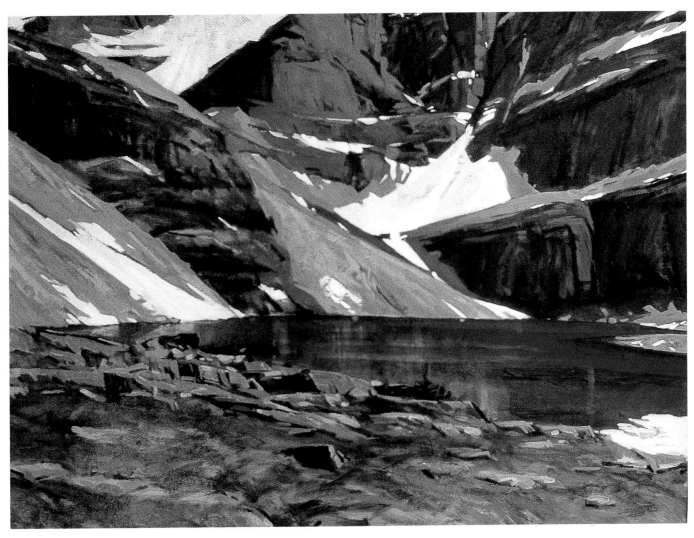

Oesa's Charm, 24 x 30" (61 x 76cm), oil on canvas
Lake Oesa is one of the Canadian Rocky Mountain jewels.
The difference here is the solitude that can still be found
on its shores because the number of visitors is restricted.

ABSTRACT SHAPE PATTERN

The design structure created by the snow patterns
in the rocks of the high alpine mountains is almost
abstract. If you have never experienced the high alpine
it must seem almost surreal. To the artist it provides
*almost endless **compositional possibilities**. All the*
design elements of a good, bold composition are
present. There is a variety of shapes with high contrast
and strong color from which to pick and choose.

What made these paintings bestsellers?

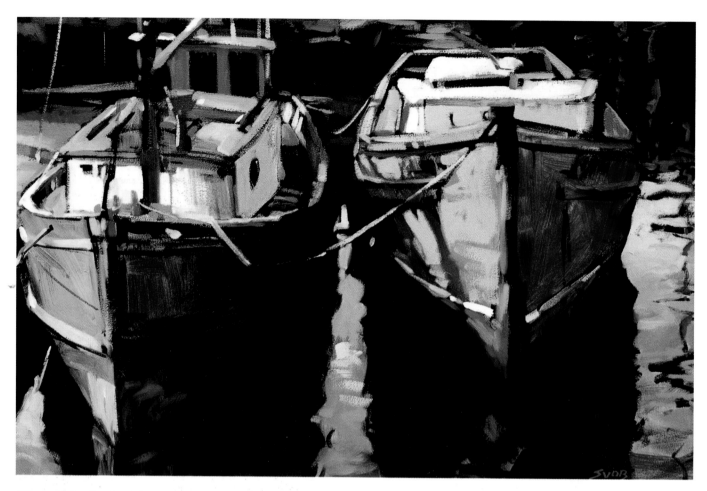

Gibson Pair, 16 x 24" (41 x 61cm), oil on panel
Converted from fishing vessels to recreational boats due to the decline of the Pacific Salmon, these boats still retain their charm. The rigging for the nets and hauling is stripped away and the hold is converted to a living area. These old working vessels are much more interesting to paint than the modern, streamlined versions.

SUPPORT PLAN

*The texture that can be seen in different places in this painting is **the result of the technique I used to apply the chalk based gesso**. This was applied with a rough roller in two coats. The support is a stiff, wooden panel. The gesso was not thinned, and the one that I find works best has a thicker consistency. The result is a tooth finish that makes the oil paint look different compared to canvas.*

What do you think buyers like about this painting?

What does this painting say to them?

What is it about the quality of the paint itself that is so attractive?

What is it about the texture of this painting that is so attractive?

What is it about the brushstrokes that is so attractive?

Can you see places where the ground shows through the layers?

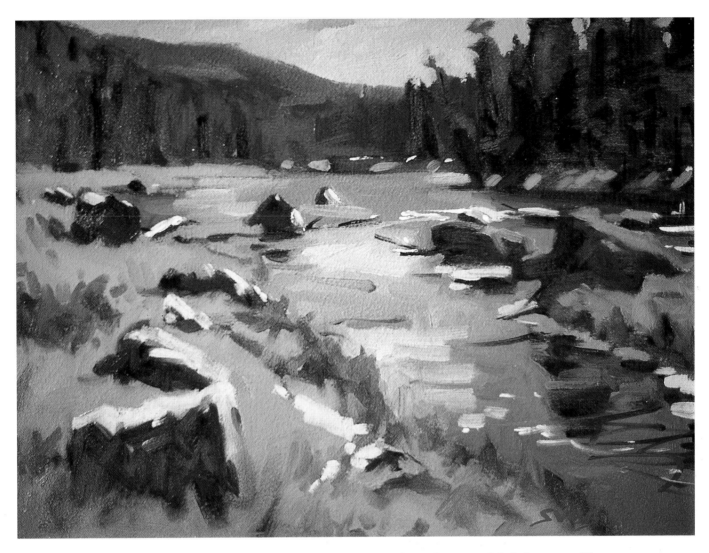

Yellowstone River, 9 x 12" (23 x 31cm), oil on panel

Yellowstone National Park is one of the great natural treasures of the world. The park and its environs provide numerous painting possibilities.

A direct approach was followed throughout this piece with most paint applications being thick and opaque. The rocks provide both a path leading the eye through the painting, and a way to create a feeling of depth: the rocks become smaller as they recede into the distance.

SUPPORT PLAN

An orange glaze was applied over the entire board and allowed to dry before I began painting.

What do you think buyers like about this painting?

What does this painting say to them?

What is it about the quality of the paint itself that is so attractive?

What is it about the texture of this painting that is so attractive?

What is it about the brushstrokes that is so attractive?

Can you see places where the ground shows through the layers?

COMPELLING DESIGN THAT

Drawing accuracy and measurement, although vitally important, are not what clinch the sale. It could be the painting's design that seals its fate.

Drawing is the primary skill of every artist. Drawing is what we do from the first mark of the pencil to the final stroke of the brush on a painting. Drawing is the individual hand-eye coordination you need to develop and hone until it becomes your personal mark. **It is the way you make your mark that distinguishes you from the next artist.** The amount of time and the mental discipline you put into your drawing will be in a direct proportion to the amount of polish and individuality your work displays. There is no drawing pill you can take, and there is no genetic predisposition to being good at it, all that is required is practice.

When is a drawing not a drawing?

The drawing we do for painting is not quite the same thing as the simple line drawings people use to symbolize objects. For example, visualize a simple ball. When drawing it, a ball can be represented symbolically by a line formed into a circle. When painting it, the ball is represented by a round shape with its own tonal value and color which is further defined by lighting conditions changing over its visible surface. So, a simple line drawing represents where the ball ends and everything else begins. In a painting there is no such line.

When we draw for painting what we are actually doing is **making a measurement of the shapes, tonal values and colors that make up the visual field.** The marks we make with our drawing or painting tools on the two-dimensional surface represent those

measurements. In fact, whether you are drawing from reality or from some other source, such as your imagination, this comparing and measuring is taking place both consciously and subconsciously.

Drawing as abstract design

In some respects, **drawing involves abstract thinking.** We are not actually drawing reality, we are drawing from reality and as such we must compromise because we are attempting to represent three dimensions on a two-dimensional surface. When drawing we are **simplifying and symbolizing** in some manner to represent our subject. In the end, a painting is what happens after we have composed and analyzed our drawing marks into a design that satisfies our vision and inspiration.

All artists, myself included, do mental gymnastics between making paintings that are either **faithful renditions of reality** as we see it, or that are more **symbolic and abstract.** There is no definitive correct answer to this conundrum. It is all a matter of taste. In the end your drawing skills, which become your painting skills, will tell you where you fit into the debate. If you let your own sensibilities be your guide, both you and the potential customer for your work will be rewarded. Your work speaks for itself. And it will speak to like minded people.

MAKES THE SALE

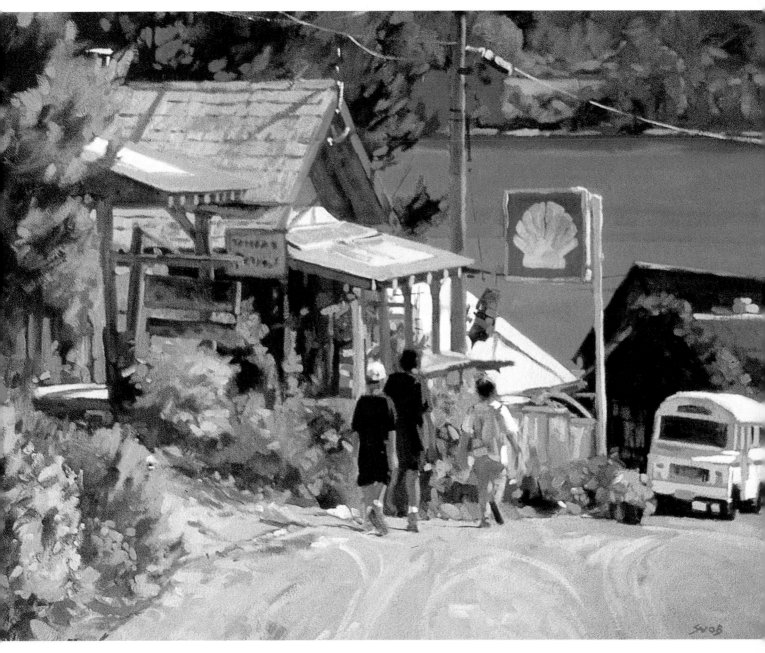

Saltspring Afternoon, 24 x 30" (61 x 76cm), oil on canvas
Figures create the focal point in this design — kids off on some Saturday afternoon mission. The main drawing challenge in this piece is the edges. There are numerous soft transitions from one shape to the next. The harder edges were saved for the area around the figures.

Soft and Hard Edges

Drawing skill is a measuring skill

To draw more accurately, you need to **measure more accurately**. Artists have come up with numerous ways to do this. Some of these methods, such as tracing out an image projected onto a canvas or other similar means, although they are quick, eliminate a good part of the mental exercise, and hand-to-eye coordination. In the short term you will save time by using these methods but in the long term this procedure will become a crutch and will hinder your drawing ability.

Ultimately, drawing and painting are so closely connected your painting technique and design will suffer. Methods that reduce what we see to basic shapes such as rectangles, triangles, circles, ellipses, cones, and so on, are better than tracing. However, I find that relying on shapes is a practice that falls short in many real painting situations.

Try this

The method I use is a more direct way that works for me, and might work for you as well.

Essentially, my method of drawing starts by choosing the format or **shape** of the painting I am going to do. It may be a horizontal or a vertical ratio of 1 x 2 or 4 x 6, or some other ratio.

The **first line** I make is the most obvious and the **largest division** in the painting. I try to get this line and each subsequent line as accurate as possible. The **second line** will be the **second most obvious and largest shape**. I continue in this way with either a pencil or a brush to lay out my painting. The

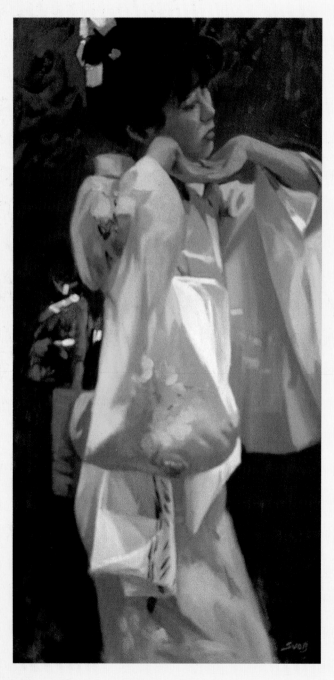

THE DIFFERENCE BETWEEN LANDSCAPE DRAWING AND FIGURE DRAWING

Tangerine Lady, 24 x 12" (61 x 31cm), oil on panel

Drawing and painting a figure that is to be the predominant design requires more attention to drawing accuracy than you would use for a landscape painting. In a landscape painting the viewer will still understand and read the shapes even if they are exaggerated or changed around. People viewing a landscape assume things are in order, just as they were present in reality.

If you begin moving and exaggerating the shapes on a figure painting it evokes quite a different reaction than a similar treatment given to a landscape. Most of us want people to look like all their parts are in the right place.

My color plan

The orange silk kimono just sang out to me. Japanese traditional costume is beautifully colored and patterned. The color in the painting is faithful to my perception of reality. Occasionally the subject has enough visual quality so that all I try to do is be faithful to my eyes. The warm Cadmiums — Yellow, Orange, and Red — were used almost exclusively to paint the orange kimono. The pattern of the green in the dress is a discord color with orange, and sets the colors moving. The background was pushed very dark to set off the figure. This painting first appeared in my chapter in the book, "Design & Composition Secrets of Professional Artists" (International Artist), and I thought it merited a further look.

ATTENTION-GETTING DESIGNS THAT SNARE BUYERS

What made these paintings bestsellers?

Rapids, 20 x 30" (51 x 76cm), oil on canvas

The movement of water, or other moving elements, can be a challenge to draw and paint. In this case, close study or a photograph become necessary. Despite the convenience of photography, when you are drawing for painting working from life is the best way. This is not because of some idea of getting in touch with our subject in some mysterious sense, but because drawing from life is just better. Our eyes are infinitely keener instruments for judging the shapes, tonal values, colors and edges that actually exist. A photograph is downright primitive in comparison to what our eyes can perceive. When you only work from photographs you limit your visual input to what the camera sees.

What makes this drawing so compelling?

Is it the viewpoint?

Is it the handling of tonal values and color?

Is it the abstract pattern of shapes?

blocking in of shapes follows in the same large to small manner, depending upon the particular painting method I am using.

I find this method of drawing and laying out my paintings helps a great deal with scaling up or enlarging from my initial thumbnails or color sketches. The fact that drawing is part of the painting and design process right from the very beginning means you must pay attention to both from the start.

Drawing without boring

Despite the necessity for good drawing, in the final analysis **an artist's primary concern should be overall design, not drawing accuracy and measurement**. To draw in your own style effectively, and to derive the maximum satisfaction from your work, make your drawing ability your slave. **Let your artist/designer side boss your artist/drawing side around.** Just be careful the designer side has some idea of why he or she is making the drawing side misbehave by not following the measurements called for by what we see. There are numerous situations in design where a **compromise** between realistic drawing and design taste could or should take place. You may want to purposely alter your drawing to **avoid repetition or monotony.** I make this a practice in my work. Some artists will never use a straight line even if one is called for. Others may only use straight lines to give their work a certain look. You may decide to design paintings that are all painted with soft edges, even though the subject calls for hard edges, or vice versa. There are innumerable ways to alter your drawing method from reality to create interesting designs.

Whatever you decide about your drawing and design decisions remember, and practice, the measurement aspect of drawing. **Continually compare shapes, edges, and colors to see if they meet your standards and satisfaction.** Continuously **correct and refine** your drawing while you paint. Do not mindlessly fill in your shapes, brushstroke after brushstroke.

Mindless into a painting, equals mindless out of that painting. In my experience the mindless do not appreciate or buy art.

***Early Conversation**, 12 x 16" (31 x 41cm), oil on panel*

Every morning these horses would gather outside our cabin and seemingly engage in quiet conversation. It was one of the few times they would hold still long enough for me to attempt a painting.

DESIGN PLAN

When drawing elements like horses, I begin by creating a box of appropriate dimensions for each one. I then compare the boxes to make sure they relate to each other in the picture plane.

In this manner the horse second from the left has a bigger, thinner box than the one to its right. Once I have the boxes in place it is a simple matter of subdividing the shapes in each box into head, back, bottom of the belly, and so on.

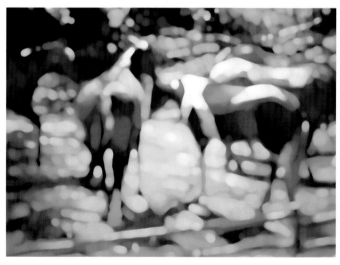

Color Patterns

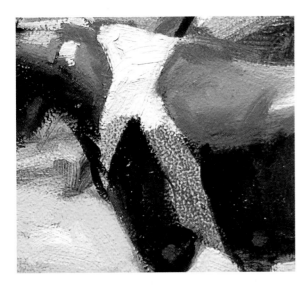

X marks the spot

The fantastic marking on this horse might just as well have been a bullseye, because it draws the eye right on target. Other design elements are the diagonal foreground fence, the subdued horse at extreme left that prevents the eye from wandering out of the picture, the lead in lines of the shadows and the strategic highlights.

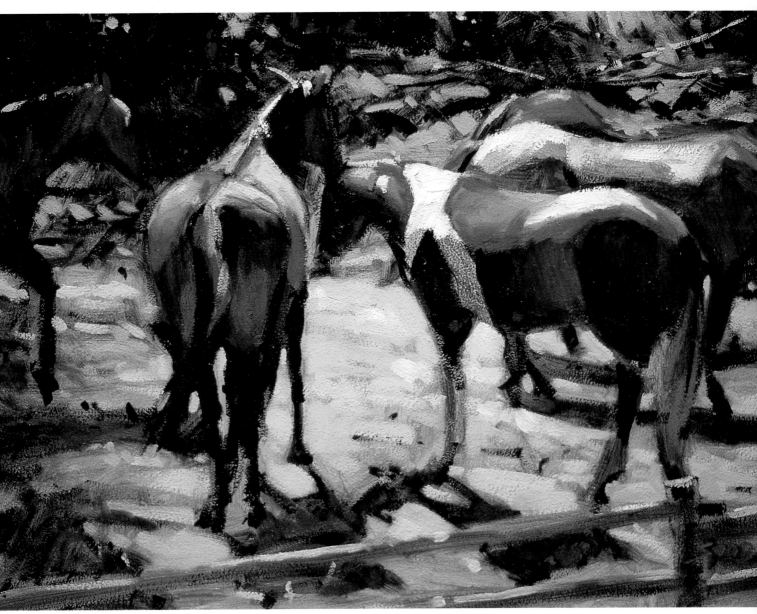

View From Above, **16 x 12" (41 x 31cm)**

A different perspective can provide an element of intrigue to a painting. We spend most of our time looking straight ahead and then painting from that same perspective. Try looking and painting from a higher or lower view. It may provide the spark of inspiration that makes a scene or subject new and vibrant again.

The old towns and cities bordering the Mediterranean were developed for foot traffic not vehicles. The result was narrow streets and numerous stairways. The up-down nature can be a refreshing change to a landscape painter. For this painting I placed the simple large shapes first, such as all the buildings on the left which were grouped and painted as one shape. Smaller elements and details were painted on top.

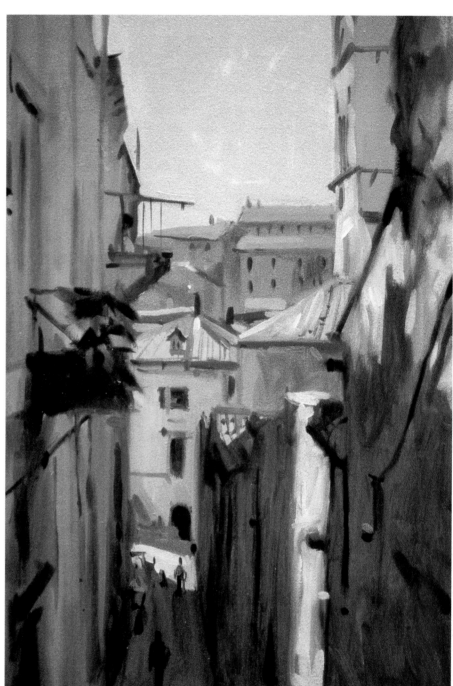

Soft edges

Mood

Mysterious

Evocative

Morning Shadows, **16 x 12" (41 x 31cm), oil on panel**
Compare the edges in this painting to "View From Above". The edges here are hard, in "View From Above" they are soft. The result of drawing the edges harder than they really are gives a more graphic look. Shapes become more distinct and symbolic.

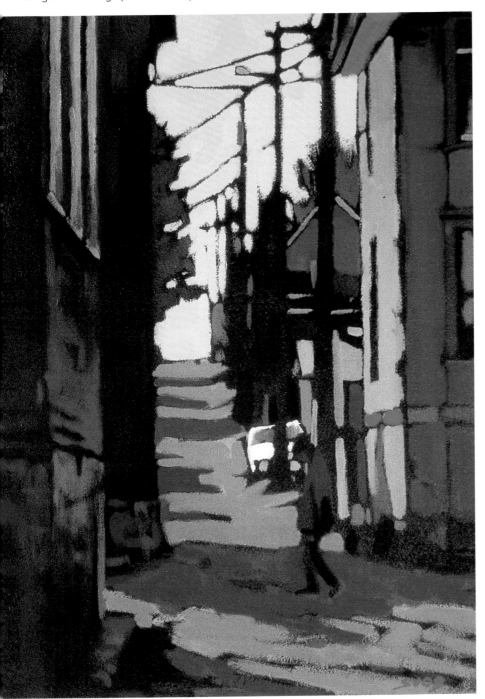

Hard edges

Graphic

Distinct

Symbolic

Fun On The Rocks,
24 x 30" (61 x 76cm), oil on canvas

The wave swept rocks in this area of West Vancouver are a light colored granite and rounded. They contrast nicely with the deep blue waters from which they rise. The nooks, crannies and tidal pools are a source of wonderment for children. They also happen to make great painting material.

To create the effect of the rock texture, a washy mixture of oil paint thinned liberally with mineral spirits was allowed to dry slowly. The resulting granulation of the pigment was rather convincing at imitating the look of granite rock. The darks were next and the highlights were added on top.

This design has a lot going for it. But see the difference when we use the computer to change important elements around.

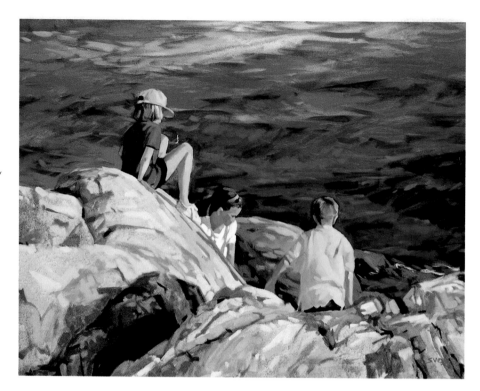

Look what happens to the painting's appeal when we remove the central figure

Removing the central figure really upsets the design because there is too much of a gap between the other kids. Small though it is, the central figure serves to link the two others, plus, her t-shirt is the lightest light, and removing her robs the painting of the extreme tonal range.

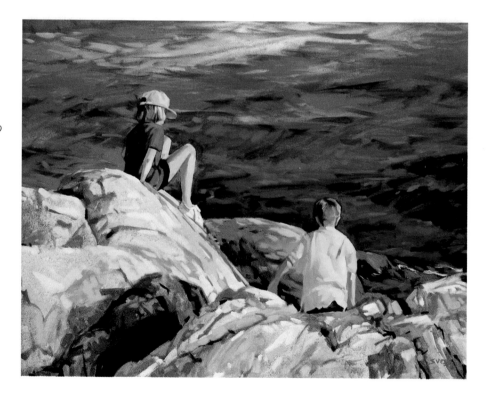

PERFECTLY GOOD DESIGN

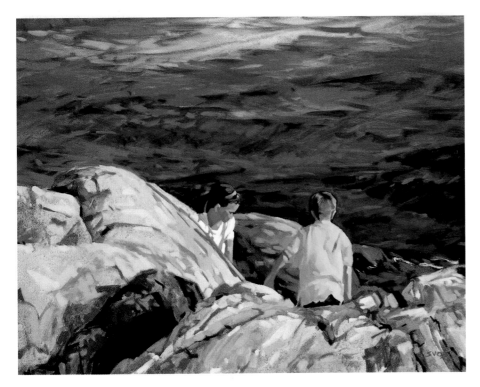

Look what happens when we remove the figure on the left

Now the design is really ruined because the girl, with her blue shirt, not only serves as a link between the rocks and the sea, but she tells a major part of the story — she's overseeing the action. There is also a certain dynamic tension in the angle of her leg and the way she is clinging to the rock.

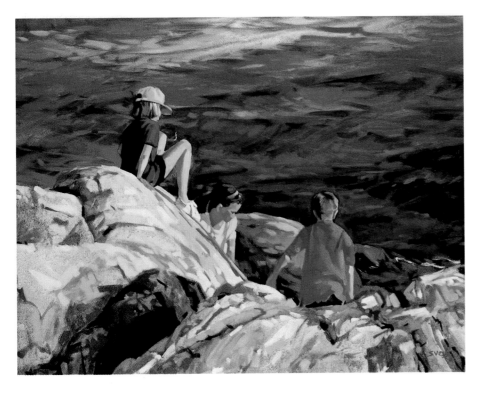

Now look what happens when we change the colors

Color also plays an important part in design.

EXERCISE

Letting your artist/designing side boss your artist/drawing side around

As discussed, drawing is essentially measuring. When you are painting, comparing is probably a better word than measuring. We compare how long one line is to another. We are not really interested in its length compared to a standard inch or millimeter. When painting we need to measure or compare much more than the length of lines. We need to compare values, shapes, edges and color temperature all at the same time. This is a very daunting task, for even the best artists. To make designing and painting easier it helps to reconstruct the subject by simplifying and doing each element separately. In this exercise we will ignore the actual edges and colors we see and instead we will focus on drawing and painting the shapes and values in our subject.

1 The reference photograph

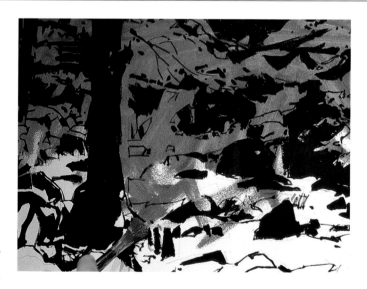

4 Apply a transparent middle value glaze over the top

Let the outline and black value shapes created in the first two steps dry completely before doing this next part. Pick a transparent, warm color on your palette to glaze over the top of your drawing. It is transparent if it does not make the black on your painting lighter when you put a thin layer over the top.

Why are we doing this? In the first steps we established the lightest and darkest values, (the lightest being the white of

the gesso). In this step we are going to establish a middle value using our transparent, warm color.

Cover the entire painting surface, both the white and the black, with your transparent color. Put enough paint on the surface so that the resulting value contrast is half-way between the white and the black.

2 Make an outline drawing

The first step is to make an outline drawing of the value shapes. I used black gesso but you can use black acrylic. Black oil paint will also work but you will have to let the black paint dry before the next step.

To make an outline drawing simply follow the value changes with a line, ignoring the actual subject matter. (Notice the way the line for the dark value shape on the tree trunk follows into the dark rock values.) Outline the shapes you see in the subject.

3 Start with the darks

With our outline done we can now fill in all the dark values using black paint. Ignore the color and small tonal value changes. Simply find your dark shapes and paint them with the black. It won't hurt. Try it.

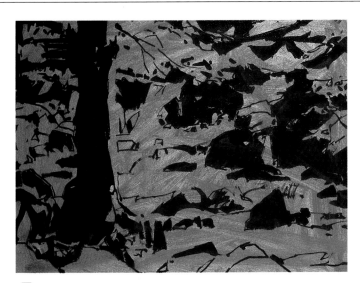

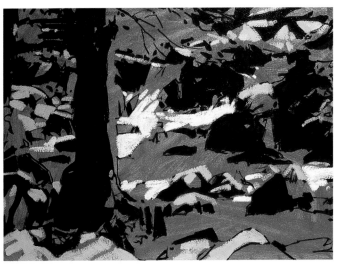

5 Glaze and set a mid value

Congratulations, you have just killed two (or more) birds with one stone. By painting the entire surface with the transparent mixture you established a color harmony and you now know how to glaze a painting. You also have your mid and dark tonal value firmly established. As a bonus the black is no longer black. However, you do have a bit of a dilemma because now the white of the canvas is gone.

6 Re-establish the lights with opaque paint

In this step, let's get the light values back. Paint in your lightest value shapes to get that light-to-middle-to-dark value drawing back. You will obviously need an opaque mixture to establish your light values. There is no need to be exact, let some of your transparent glaze show. Now you will have learned to measure something else. And because you have actually used them you know how opaque or transparent certain pigments are.

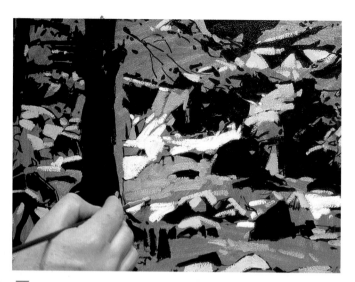 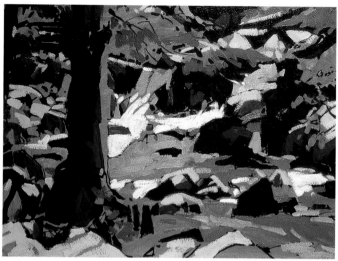

7 **Now introduce different color temperatures**
Paint your mid value shapes warmer or cooler than the transparent glaze used in the last step. Try a mixture of Ultramarine Blue and Titanium White to establish a cool color. Apply this cool color wherever it corresponds with the subject.

8 **Finish up by painting in all the shapes that remain**
Be sure to compare your drawing/painting shapes, value, and color with your subject. There is no need to match color exactly, just simplify it to a cooler or warmer idea of color.

Compare the shapes of dark and light and note the color temperature changes

Light Shapes

Highlights

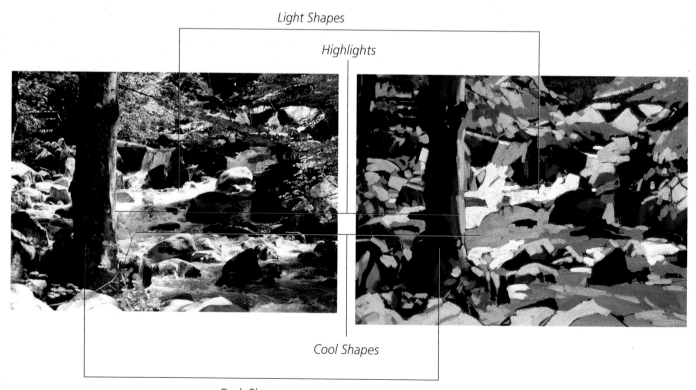

Cool Shapes

Dark Shapes

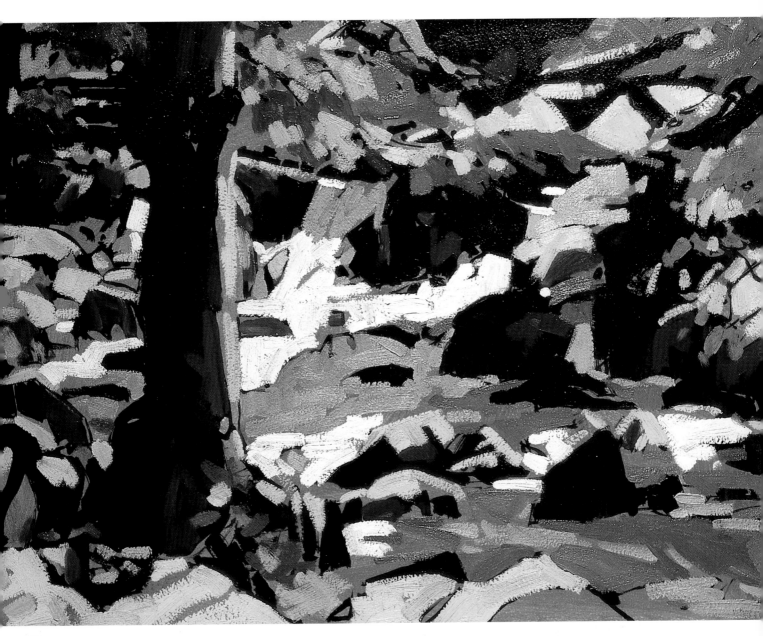

9 Finished — *Shannon River*,
9 x 12" (23 x 31cm), oil on panel
That's it we're done. Keep your painting because it will remind you of all the things you have learned by doing this exercise in drawing to paint. Compare this demo exercise to the painting "Rapids" on page 35. It does not differ very much.

ASSIGNMENT NOW DO ANOTHER ONE

You've got the idea from following the exercise. Now do another one. To do this assignment, as always, you will need a good reference. Find subject matter, a photo or otherwise, where you can clearly see a wide range of tonal values and shapes. Pick something you have been just itching to paint. Then go to it. Remember what we did in the exercise and follow those steps.

PUTTING BUYERS IN THE PICTURE

Think of tonal values as your painting map and follow it, because this will enable buyers to get your point immediately.

Tonal values are the meat and potatoes of painting. A tonal value is simply how dark or how light a shape appears to the human eye. Tonal value has nothing to do with color. **Tonal values allow us to determine virtually all the visual information we see.** In a (tonal values only) black and white landscape photograph you can tell where the sky ends and the land begins. Each object will either have its own separate tonal value or we will see it as part of a larger shape. In this way the trees become a forest or the grass becomes a lawn. From a distance our eyes perceive the trees on a hillside as a single tonal value. Up close, each tree takes on its own shape. Move even closer and the leaves take on individual shapes.

To be able to paint any subject we must be able to discern the tonal values and shapes that constitute that subject. We must measure and compare the tonal value we see with what we are doing in our drawing or painting. **Our eyes can distinguish far more tonal values in our subject than we will be able to paint in our paintings.** To simplify the number of tonal values we paint in our paintings we begin by organizing or **grouping the tonal values** we see in our subject. In effect we must **limit** ourselves to a certain number of **tonal values** from the lightest to the darkest.

Pinpoint the tonal values

I use two different methods to help me get a grasp of the tonal values in my subject. The first is to squint and the second is to make a thumbnail sketch of the tonal values.

Squinting is a good way to perceive tonal values or to group tonal values when painting from life. When we squint, some tonal values group together to form a new, broader shape; for example, the trees become a forest. Squinting also helps to establish which tonal value or group of tonal values is lighter or darker. Squinting does not help with color. DO NOT SQUINT WHEN COMPARING COLOR OR TONAL VALUE IN YOUR PAINTINGS. In this case you need to judge your work with your eyes wide open. After all, that's what the viewers will do. Practice squinting when painting from life. It works. Trust what you see and paint what you see when you squint.

By grouping or limiting the number of

WITH TONAL VALUES

tonal values we paint it is possible to give our painting more **contrast** in the places we want **to draw the viewer's eye**. We give our paintings better **design structure** and make our painting **more easily understood**.

Reduce everything into three groups

The way I go about simplifying my tonal value structure is to group my tonal values as follows. First, I will group, remove, or otherwise alter the tonal value structure until my painting idea is reduced to a light, a mid-tone and a dark. This reveals the **broad structure** of the composition. If I am in doubt at all about the design I will make a small **thumbnail sketch** of the tonal values.

When working from a photograph or, as I do in the studio, from a slide projected onto a screen, I simplify the tonal value structure into a thumbnail with a light, a mid, and dark value. I do this religiously. No fourth value is allowed. No two-value thumbnail will work. I follow this rule whether painting on location or in the studio. **The three-value**

pattern I see or create in my thumbnail **is my painting map. The big creative decisions are made on this tonal value map.** Once I determine what the large tonal value changes and shapes are in my thumbnail I stick to it.

This whole process takes only a few minutes for each thumbnail sketch. I don't proceed to the painting stage unless I'm completely happy with my thumbnail. Some very sage advice given to me when I was an aspiring artist was this bit about thumbnails:

"If you can't do a good three-value thumbnail design that excites and inspires you, attempting to paint will only lead to disappointment and be a waste of time."

Being a rebel, like most artists, I spent years trying to refute this advice. Invariably, almost every bad painting design I have done (and I have done thousands) is the result of ignoring this advice. Of course, other things can and do go wrong but ignoring the preliminary design is by far the biggest time and material wasting mistake you will make as an artist. Let's be positive and give

ourselves the greatest chance of success when we paint.

DO THE PRELIMINARY STUFF.

Then subdivide your groups

At the painting stage, three values will not provide enough tonal value changes to bring out the desired shapes. When painting the tonal values I will now allow myself to break each of the light, mid, and dark values found in the thumbnail into two or three values as required. In this way a tonal value structure from one to nine is created. **Nine values are sufficient to represent virtually anything we paint.**

In addition to using tonal value changes to show different shapes we can also use color. **Color can be used where a tonal value change is not desirable.** In painting we can use as many color changes as we want without affecting the basic structure and design of our picture.

Get your tonal values right and you will be rewarded in your painting structure and design.

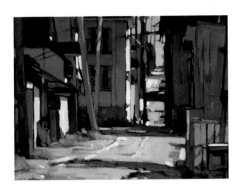 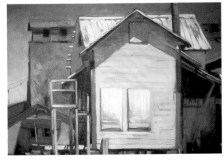 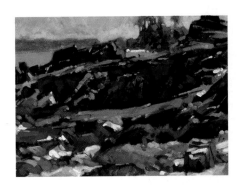

As long as you are faithful to the shapes, tonal values and edges you see in your subject, color can be pushed in any direction and still be believable.

EXERCISE

I made a painting of this Kenyan market using the same source material in the mid-1980s. It was an acrylic version and I always thought it would make a good exercise in tonal values so let's try it here. We will begin the painting using black acrylic to establish the basic tonal value pattern, then we will finish off the exercise in oil. Many oil painters work in this manner. The reason for beginning with acrylic is to speed up the drying process.

We will develop the edges, tonal values, and shapes to an almost finished state. Then, to finish off, glazes and more opaque thick passages of paint will be used. Before we begin the painting we will make a thumbnail tonal value sketch of the subject to simplify the design.

1 **How to make a tonal value thumbnail map**

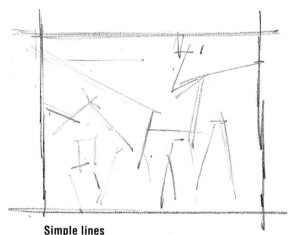

Simple lines
Lay out your drawing with simple lines.

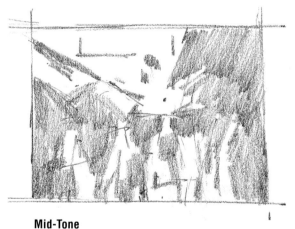

Mid-Tone
Leave the white of the paper for the lightest value. Cover everything that is mid-tone or darker.

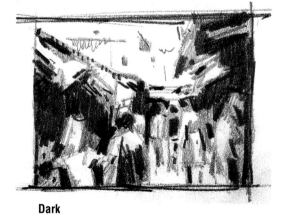

Dark
Put in the darkest value, pushing hard on the pencil.

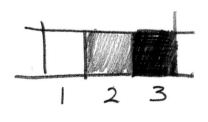

Scale of Tonal Value

48

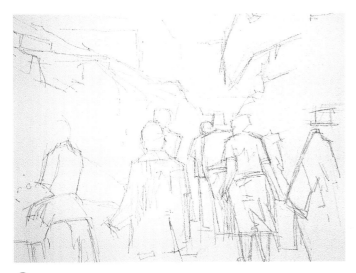

2 Make an outline drawing

I used a 12 x 16" (31 x 41cm) white gessoed panel, but you can use a canvas board or canvas if you wish. Begin by making a simple pencil outline drawing of the shapes. The drawing is important to get the overall layout accurate without getting into detail. It is important to follow the proportions and shapes of the tonal values established in the thumbnail.

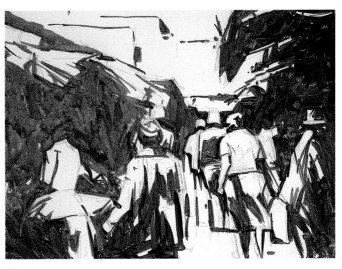

3 Start on the tonal values

The tonal value principles established in the thumbnail should be carried through into the painting. First, paint all the shapes that will be mid value or dark tonal value, making no distinction between them. This is a good thing.

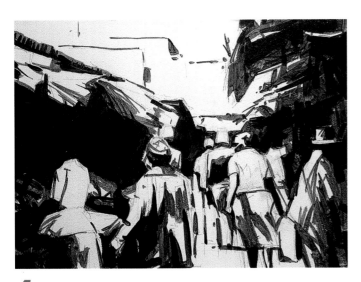

4 Establish the design

Paint the dark tonal values over the mid-tone values wherever called for by the subject. The tonal value pattern on your support should now closely resemble your thumbnail. The basic design and composition is now set for the painting.

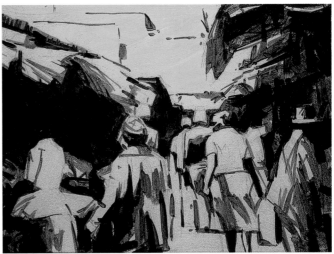

5 Apply the underpainting

Once the basic composition is established you can have some fun with the color. To keep it simple, apply a glaze of Indian Yellow over the entire panel. (I mixed alkyd with mine to speed up the drying.) A good warm underpainting has now been established.

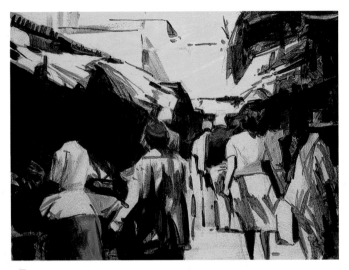

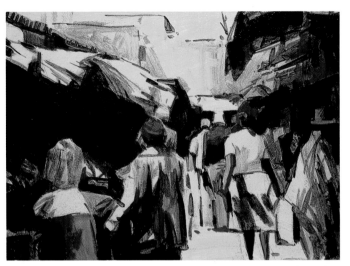

6 Adjust the tonal values

Use transparent glazes of cool and warm color to adjust tonal value and color where the subject calls for it. Pay more attention to tonal values than color throughout the process.

7 Keep your focus

Ignore the edges and focus on the tonal values, shapes, and color.

8 Move to opaque paint

At this point, when you feel the tonal values are well established with transparent mixtures, it is time to use opaque mixtures. To get the tonal value range more or less complete, the white shirts on some of the figures can be done next. With the lightest value through to the darkest value finished on the painting, you can now focus on areas of color temperature. Note how the sky in this stage was painted a cool light blue to separate it from the building shapes. Similarly, the ground was painted a cooler shade of brown to separate it from the dominating Indian Yellow glaze.

Continue in this manner refining color by applying cooler or warmer opaque passages, being careful not to alter the basic tonal value pattern.

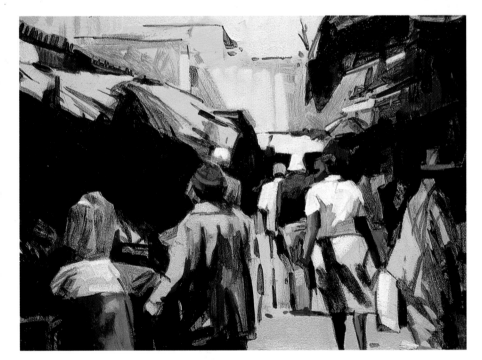

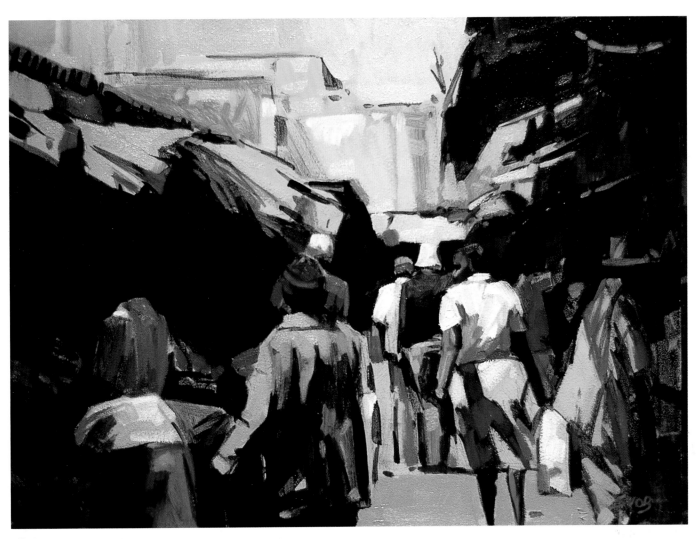

9 Kenyan Market Finished

Done. I think. You know they are never really done. If I leave a painting in my studio I will inevitably go and paint on it at some point. It is a good idea to quit on a painting when you have completed your original plan. Do not second-guess yourself.

Note the tonal value changes in the painting. The statement created is bold because of this.

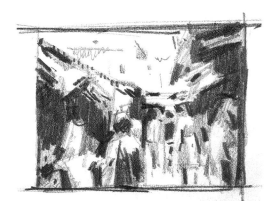

Did you stick with it?

Compare your tonal value sketch with your finished painting to see if you stuck to your plan.

SELF EVALUATION

How did you handle this exercise?

What did you find most difficult?

What did you find easy?

Do you understand the concept of dividing what you see into light, mid-tone and dark tonal values?

Were you able to identify the different tonal values?

Will you always make a tonal value map first from now on?

51

What made these paintings bestsellers?

Alley Pattern,
12 x 16" (31 x 41cm), oil on panel

Creating a vision in paint comes partly from knowing the limitations — what is possible and what is not possible. You must have some grasp of what you are capable of and what works for you. In my case, I enjoy changing and pushing color to create a plausible reality — one that I would like to see.

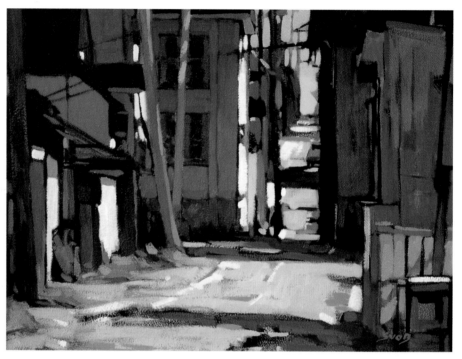

Tonal Value Map

The overall tonal value pattern in this painting is fairly easy to see. The light gives way to the mid-tones and these in turn give way to the darks. The light is warm, the shadows cool.

Things I changed in this scene

You are in charge of this thing called painting. Take it where you want it to go. Change things if you want to. For instance, the brown fence in the lower right of the painting began as a white fence. However, it had too much contrast. The solution was to reduce the tonal value contrast while keeping the color contrast — so I changed it to a brown fence. See how it would have looked in the small image.

. . . ignoring the preliminary design is by far the biggest time and material wasting mistake you will make as an artist.

VALUE MAP

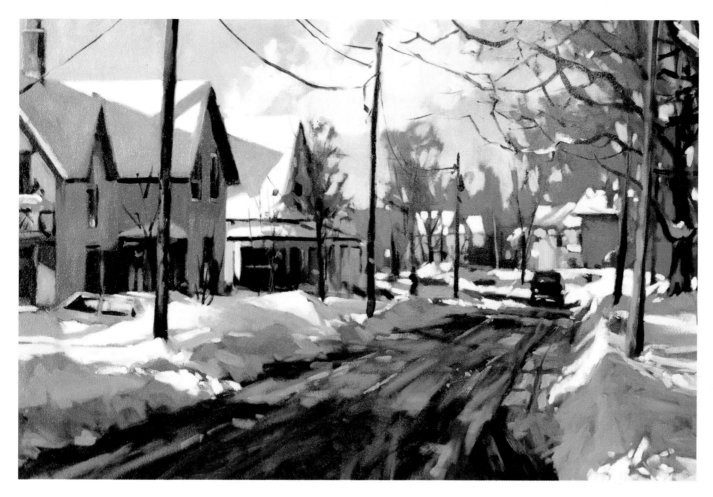

Slippery Streets, 16 x 24" (41 x 61cm), oil on panel

Snow is an inspiring thing to paint if you can get past the fact that it's cold outside. Living in Canada you get your fair share of inspiration in this form. This snow scene represents my wife Nancy's home town of Grimsby. We were visiting when over 20 inches of snow fell overnight. However, the next day was sunny and calm — a rare opportunity — so I took full advantage of the weather. I spent the next several days furiously gathering imagery from which this and many other paintings were produced.

What's the story in this scene?

How do you feel when you look at this painting?

Can you imagine being there?

What does it remind you of?

Tonal Value Map

When it comes to organizing and painting your tonal values, painting snow is relatively simple. Invariably, the snow will be the lightest tonal value.

What made these paintings bestsellers?

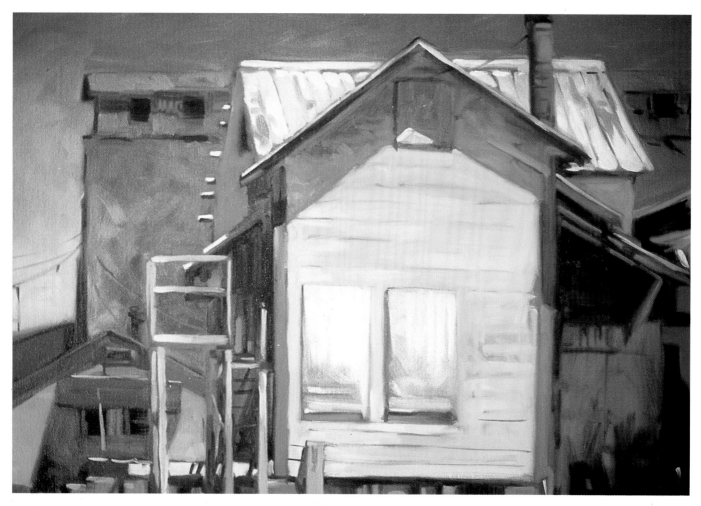

Peanut Factory, 16 x 20" (41 x 51cm), oil on panel
An Alabama peanut factory was the subject for this study in shapes. I was intrigued by the angular and rectangular shapes in the buildings. An interesting lesson this study gives is that a warmer color will look lighter in tonal value than a cooler color.

Tonal Value Map

Question: Is the shadow area under the roofline darker than the sky?

Answer: The shadows under the roofline of the building in front are darker in tonal value than the sky behind it. At first blush there is a tendency to read the warmer color as lighter in tonal value than the cooler color. Remember, the trick to judging tonal values is to squint and compare. If you do this you will see that the shadow area is darker in tonal value.

What's the story in this scene?

How do you feel when you look at this painting?

Can you imagine being there?

What does it remind you of?

Is there anything in this painting that you can adapt for your own work?

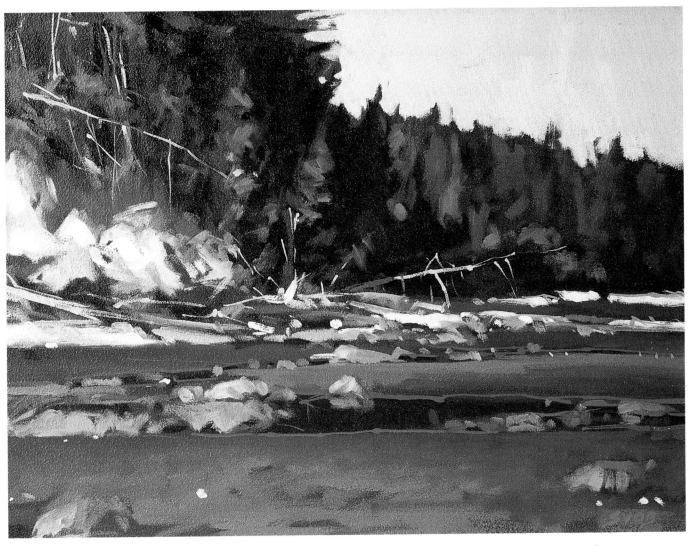

Savary Beach, 12 x 16" (31 x 41cm), oil on panel
Savary Island has beautiful sandy beaches that are sprinkled with tidal pools and boulders. The eroding cliff and trees above add an interesting backdrop to the beach. The reason the painting hangs together well is due to the tonal value relationships.

What's the story in this scene?

How do you feel when you look at this painting?

Can you imagine being there?

What does it remind you of?

Is there anything in this painting that you can adapt for your own work?

Tonal Value Map
The technique used for this painting was direct, with very little overpainting. I began with the largest and most obvious dark tonal values, then moved to the large mid-tones and last the larger, light value shapes. Smaller, more detailed shapes were painted wet-into-wet, blending edges as I went.

What made these paintings bestsellers?

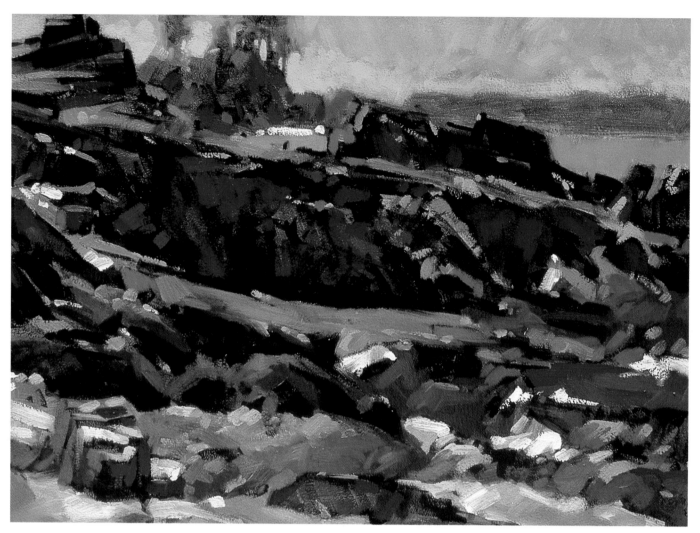

Rocky Shore, 12 x 16" (31 x 41cm), oil on panel

I found the pattern of light and shadow in this Queen Charlotte Island scene interesting, but it lacked color pizzazz. To keep what I liked in the subject I stayed true to the tonal value pattern in the preliminary drawing. The color was exaggerated toward the warm end. As long as you are faithful to the shapes, tonal values and edges you see in your subject, color can be pushed in any direction and still be believable.

What's the story in this scene?

How do you feel when you look at this painting?

Can you imagine being there?

What does it remind you of?

Can you use a complementary blue/orange color scheme in your own work?

Tonal Value Map

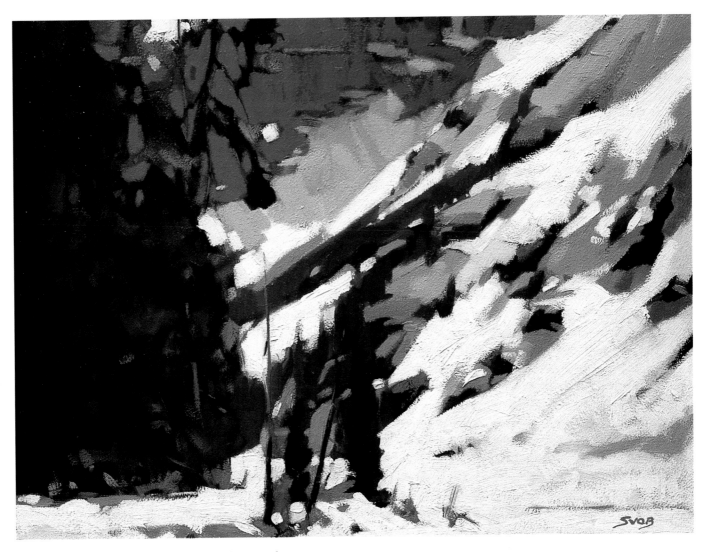

Avalanche Slope, 12 x 16" (31 x 41cm), oil on panel

The design here exhibits a strong diagonal, which is a theme I use quite often in my paintings. Sometimes I will not even be aware of it until the painting is finished.

There is quite a build-up of paint on this panel that was not part of my original intention.

The first go at this subject was not satisfactory, so the painting haunted my studio for almost a year before I went back to it. I painted the second attempt over the top of the first painting, but it turned out to be worse than the original. The painting you see here is version number four which is mostly made up, but successful.

The painting process in this case is neither desirable nor teachable but it does show that there is something to be said for perseverance. In the end it is quite a simple design and exhibits a good tonal value relationship.

Tonal Value Map
It's almost an abstract with a strong diagonal when viewed this way.

WARM UP YOUR SALES WITH THE

Color is an emotional tug at the heartstrings. And it helps to know that warm colored paintings outsell cool ones by a country mile.

Color is the most talked about aspect of painting. Color is the subject of endless analyses both from a scientific angle, (the theory of color), and from the artistic side, (the color wheel, color complements, analogous color, discord color, and so on).

Computers can break color down into minute variations. The human eye can supposedly recognize over twenty million colors. Wow! Every person in London and Paris could be recognized by their own color, and there would still be millions of colors left over. This chapter will not go into all the well-worn theories and solutions to color problems in painting, but it will give you what I actually understand and practice in my work.

The role of shape and tonal value

We understand the world by shapes and tonal value alone. Color is not necessary. To demonstrate that this is true, just look at a black and white photograph. The image has no color, yet everything makes complete sense. You know an orange is orange by its shape, value and association with other objects. **Color need not be a complicated subject.** Color can be easily changed without affecting the basic structure of a design.

I believe picking the correct color to use in your painting is one of the simplest of considerations. **Only use colors you like — no others.** You can use color to emotionally elevate your painting above the basic information so the buyer looks at your paintings first. You can use color to draw the viewer in, like bees to a flower, or a bear to honey. Effective use of color is often what separates paintings from one another. It is what may change a merely good painting into one that is compelling. **Effective color can create an irresistible connection between the painting and the viewer.**

So how do you achieve effective use of color in painting? The following often seems nonsensical to the uninitiated yet it may be the best most practical way to create emotional, visionary color.

Try and resolve values, shapes, edges and drawing before even thinking about color.

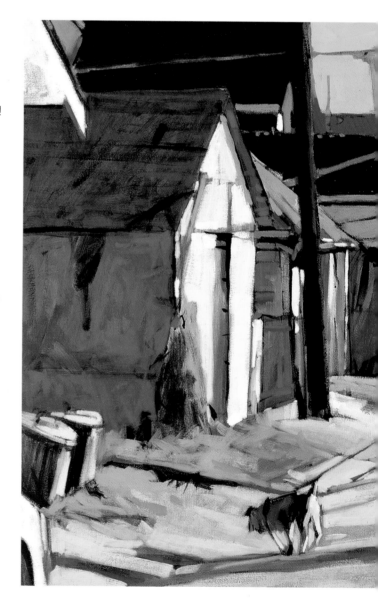

Continued on page 62

DIRECT LOCAL COLOR METHOD

COLOR PLAN USED HERE

EXAGGERATED COLOR TEMPERATURES

The hot colors in this painting were played against some very cool colors in the shadow areas. The lighting was very warm and I just exaggerated the color temperatures. The big change from reality is the color of the sky. The sky was painted with Cadmium Yellow Deep and a touch of Viridian Green.

Evening Stroll, 24 x 40" (61 x 102cm), oil on canvas
Nancy and Jasper out for an evening walk. Placing of figures in a landscape such as this makes them the focal point. Our eyes tend to immediately zoom in on any signs of life in a painting.

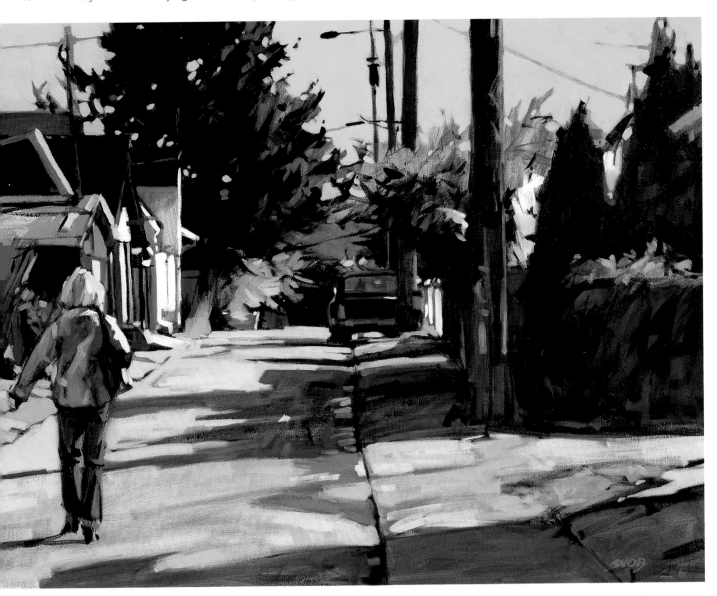

TURNING BUYERS ON WITH COLOR

What makes one painting more appealing than another?

Look at these two paintings of the same scene. The first one was painted in cool colors. The second one was painted using warm colors. Actually, "hot" would be a better description. Look at the palette I used and you'll see why this painting vibrates in the way it does. The colors are from the opposite sides of the color wheel.

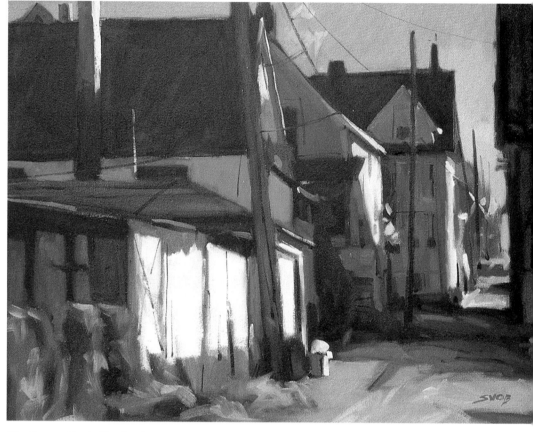

***Strathcona Cool**, 12 x 16" (23 x 31cm), oil on panel*
The painting represents an area of Old Vancouver that has a charming, ramshackle quality. The houses, sheds and garages, seem to be placed almost at random. Great stuff for a painter to work from. I have painted this alley many times in all seasons. This version is one of the cooler color schemes I have used to describe this little gem of a location.

COOL!

TWO MORE!

***Biker's Alley**, 24 x 36" (61 x 91cm), oil*
Now compare these two. I used a different color combination in each version in an attempt to thoroughly explore the subject. In the end, each version will appeal to someone, depending upon their color preference.

As long as the design structure represented by the values and shapes is interesting, the choice of color is arbitrary.

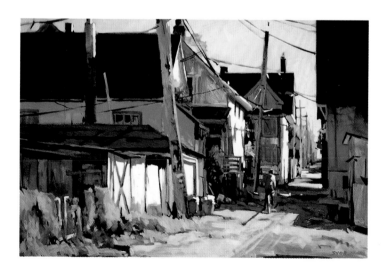

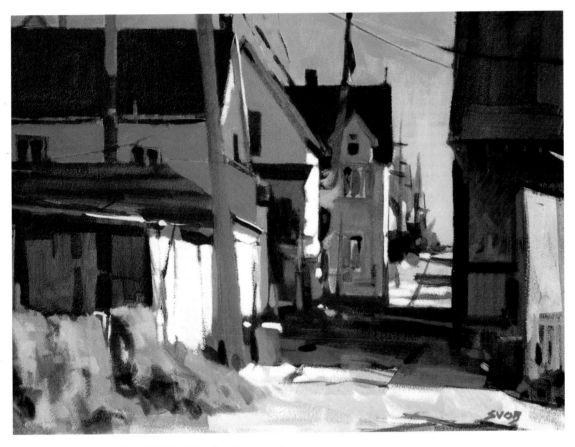

Strathcona Sunset, 12 x 16" (23 x 31cm), oil on panel
Now look at this warm, almost hot version of the scene. The values and shapes are very similar but the overall color temperature is vastly different. Which one is more appealing — the warm or cool version?

HOT!

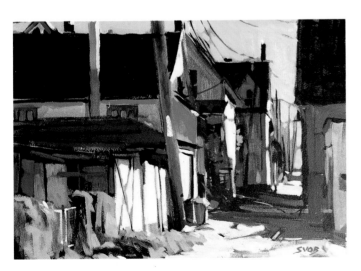

Strathcona Sunset,
12 x 16" (31 x 41cm), oil

As a general guide, visually transparent passages of paint are more appealing than opaque passages.

MY RED HOT COLOR PALETTE
The pigments I use on a regular basis are arranged here.

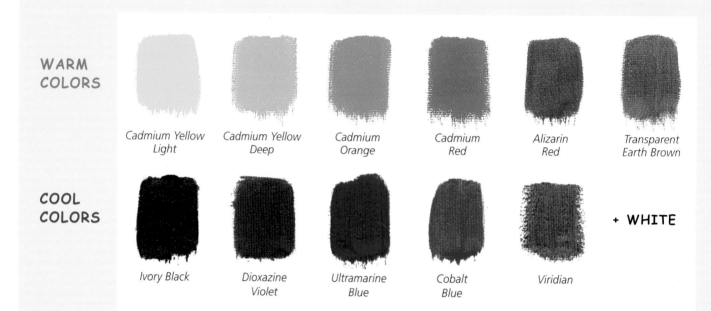

WARM COLORS

Cadmium Yellow Light Cadmium Yellow Deep Cadmium Orange Cadmium Red Alizarin Red Transparent Earth Brown

COOL COLORS

Ivory Black Dioxazine Violet Ultramarine Blue Cobalt Blue Viridian

+ WHITE

Continued from page 58

The former must be worked out first. Before you snicker and cast this aside, imagine the following. If a painting is an interesting, effective composition, done entirely in value or tone from black and white, it will stand on its own. Ansel Adams, and other photographers, used black and white photography to achieve stunning depth and subtlety. How would color add to these great images? If you simply cast a black and white image in shades of red, or violet, or any color choice, and then showed them to a group of people, they would all pick one color or another depending upon whether they have an emotional connection to that particular color. **Each would choose their favorite color.**

So what color is the best choice in any given situation?

The answer is of course a trade-off between your **emotional feeling** and what your **eyes perceive** in front of you.

The most obvious solution, and quite often the most appealing, is to use the colors we actually see in front of us. If you can see the color, mix it on your palette and place it on the painting in the right spot, giving it the correct shape and edge, and it will usually work well. That seems simple, and very often is. If you follow this practice, your color selections in the finished painting will seem entirely natural and look like they belong. They will be right. Some of the best painters, past and present, followed this procedure. Singer Sargent used this approach to great effect a century ago.

In my work I sometimes follow this method, but will often **push color** in different ways to try to create something more to my vision or emotional liking. **I will try to create something that seems plausible or realistic yet has that extra color zip that** captures the viewer's imagination and emotion. I will continuously try new color combinations or constructs of color that may or may not work. When the color works it is like magic. When it falls short it becomes what you call a learning experience. To a large extent this is what makes painting such an enchanting and intriguing exercise, not to mention a creative one.

Understand color temperature

The most important aspect of color to deal with in painting is the idea of warm and cool color. This idea of one pigment (or blend of pigments) being warmer or cooler than another is the basic concept of color that an artist needs to grasp. See the pigments in the accompanying sidebar.

On the top row, are the warm pigments Cadmium Yellow, Orange and Red.

On the bottom row, Cobalt Blue is the coolest pigment and this row is cool.

The paints on my palette lead from the lightest in value to the darkest. The paints are also loosely arranged from warm to cool.

The benefit of organizing my palette in this manner is twofold. First, it helps me avoid the tendency to lighten the value of a pigment by adding white to it. BEWARE: Adding white to any pigment not only lightens the value, it cools the color temperature — something that is often not what is called for. In the situation where I want to lighten the value of a pigment and not make it cooler, I try to use the pigment next to it on my palette.

In this way I would lighten the value of Cadmium Red by using Cadmium Orange. Doing it this way keeps the color much more intense and warm.

When I want to darken a pigment I do it the other way — my first choice is the next darkest pigment on my palette. In this way Alizarin Red would be darkened in value by using Transparent Earth Red.

The second advantage of having my palette organized this way is having what I consider cooler pigments on one side, and warmer pigments on the other. My color choices are in some respects very broad, and they are determined by

this warm to cool arrangement.

I will often add one or more other pigments to my palette, such as
Transparent or Indian Yellow,
Lemon Yellow,
Red Rose or Carmine Red,
Cobalt and Manganese Violet
and Cerulean Blue.

On a color wheel the pigments directly across from each other are called complementary colors. The pigments one-third of the way around the color wheel in either direction are called the discord colors.

To my eyes it is splitting hairs deciding which of these is the warmest or coolest, and it is of little practical benefit.

A general guide to color

On any palette, or in any painting, there will be warmer shapes and cooler shapes. To a large degree this play of warm and cool will help solve many painting dilemmas provided you follow a few simple guides or general ideas. These guides can be used to help achieve an effect of distance, or atmosphere, and provide color solutions in different types of lighting. These are the basic concepts of color and atmosphere I follow in my work, as do most painters.

- First, to achieve a degree of depth or atmosphere in a painting, you will find it useful to know that cool colors tend to recede, and warm colors tend to advance. **Objects in the distance will appear bluer or cooler than objects in the foreground.** Remember, you will not always see this in reality — warmer colors do occasionally appear in the distance. Try not to let reality get in the way of a good design. If you think warm is appropriate in the distance, so be it. Ultimately, this will tend to advance this part of the painting but the design takes precedence over the general rule.

- A second useful guide is to think about using color in terms of warm and cool to help give your paintings a sense of light that is realistic or believable. The general rule in this case is: **If the light on the object is warm, you will have cool shadows. If the light on the subject is cool, you will have warm shadows.** When in doubt about the color relationship anywhere in the painting follow the foregoing guide.

This idea of cool light with warm shadow, and vice versa, applies to any particular shape or object that has a specific color and value throughout. For example, if you picture a red dress (or any other object) in let's say a cool light, the shadows will be warmer red than the areas that are directly lit by the light source. In practical terms the red, maybe Alizarin, can be cooled by adding white (white is the coolest pigment) or blues, greens, violets, or any other pigment that is cooler than Alizarin.

In a case where the light is warm, the shadows of the red dress could now be cooled with the addition of the cooler pigments such as blues, violets or greens. **Very often the challenge is making the lighter areas warmer, as well as lighter in value.** In this case white will not work on its own, since it will make the red cooler, and break the guide of using warmer light with cooler shadows. The solution is to pick one of the other warmer, and lighter in value pigments,

Continued on page 66

USING RED HOT COLOR

What made these paintings bestsellers?

The Pumpkin Patch,
18 x 24" (46 x 61cm),
oil on canvas

Here sits my son Elliott, Lord of the Pumpkin Patch. I think this painting made him look a little sterner than he really is. Even by this age, he was so used to being painted or photographed that he thought it was completely normal. The result is that he looks natural.

The painting technique here is more direct and close to realistic color than I usually follow. Drawing skills were important to the look of this painting. I wanted the figure to be a faithful representation of my son. The figure was completed first allowing the rest of the painting to be left in a more unfinished state, and still work as part of the design. The pumpkins in the middle distance were merely suggested with a few brushstrokes.

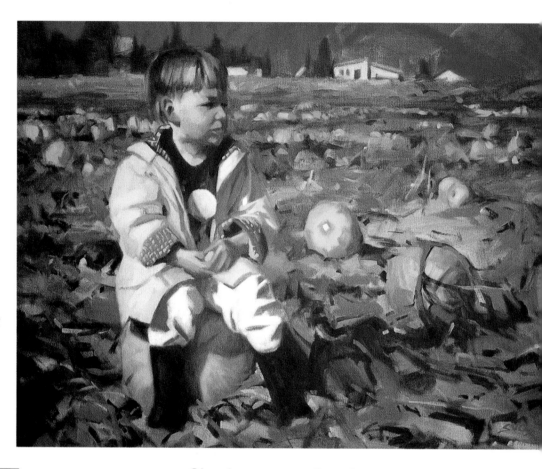

COLOR PLAN USED HERE

REALISTIC COLOR

The colors are very close to realistic, something I rarely do in my paintings. In the final analysis it does not matter to me whether I am true to reality. The look of the painting is what counts not the actual reality.

Check your emotional response to the color in this painting

What do I like about the color in this painting?

How does this painting speak to me?

What color ideas can I use in my own work?

How would I do it differently?

Montana Hillside Houses, 16 x 24" (41 x 61cm), oil on panel
The perspective of looking up the hill to the distant structures drew me to this subject. This part of Western Montana is dotted with abandoned mining towns.

CONTRAST OF VALUE AND COLOR

The panel for this painting was toned with Transparent Earth Red and Dioxazine Violet after drawing in with black gesso. Glazing over the black pushed the value of the darks as dark as possible. The saturated Cadmium Reds, Oranges and Yellows appear brilliant in contrast. The lightest and whitest values are a broad value jump again from these Cadmium colors. The combination of these values and colors give the painting its strong visual impact.

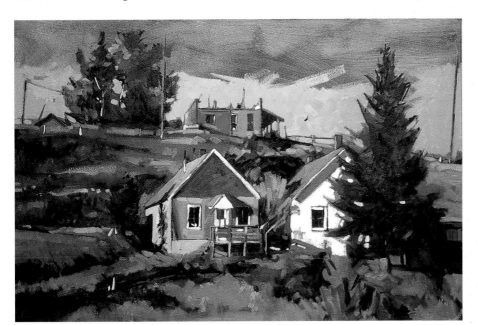

Check your emotional response to the color in this painting

What do I like about the color in this painting?

How does this painting speak to me?

What color ideas can I use in my own work?

How would I do it differently?

Do I see where color was used to direct the eye?

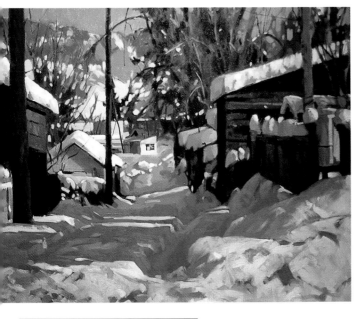

Princeton Snow, 24 x 30" (61 x 76cm), oil on canvas
Snow is one of my many favorite subjects. It is important to keep the overall relationship either warm or cool even when painting things such as snow or water. The tendency with both of these is to paint them too blue. Usually, water and snow reflect the colors around them and can be believable in almost any color. The more important considerations when handling these surfaces are often value and edges.

Check your emotional response to the color in this painting

What do I like about the color in this painting?

How does this painting speak to me?

What color ideas can I use in my own work?

How would I do it differently?

Can I identify the warm areas and the cool areas?

CONTRAST

The snow provided great contrast to play against other values.

Continued from page 63

Cadmium Yellow or another warmer pigment that will lighten the value sufficiently, will work.

Use color to lead the eye

You can use color to design a painting that draws the viewer's eye to one part of the painting over another. **Color contrast** on its own can be used to draw attention to any part of the painting. If the painting has a warm cast of light or color harmony that flows across it, any color that contrasts with this will draw the eye. **The more contrast, the greater the attention.** If a painting has color harmony on the red-violet side, you can make something seem to jump right out and grab you by using some high key color, like green or blue, to create visual interest.

Colors that are commonly considered **complementary**, red-green, orange-blue, and yellow-violet, do tend to sit more comfortably beside each other. In many paintings you may want the vibration (the sense of not sitting still with each other) found in the **discord colors**, such as purple-green, red-blue, or orange-violet. **In my method, design takes precedence over all the usual solutions.** What is ultimately important is to let your eye tell you what works and what does not. Only when you are not sure, or it is not important for your overall design, should you follow the so called guides to color.

It's true — buyers prefer warm colors

A very useful observation about color I have gained from years of painting and watching viewer reaction, is how cool or warm color harmony in a painting appeals to the general public. People tend to prefer warmer paintings to cooler ones. It is human nature. Where I live on the west coast of Canada the light and the colors found are cool blues, greens and violets. I do not follow what I see. Instead, I warm the painting in its entirety, even though it is not what I see in front of me.

People prefer warm. If you hang around your travel agency long enough you'll see it is a very rare bird indeed that books a vacation

A COLOR EXPERIMENT

Blending reality with wild color

Morning Alley, 9 x 12" (23 x 31cm), oil on panel
Trying out new techniques is very important to keep yourself moving ahead as an artist. Experimentation keeps your interest up and your work looking fresh. This was one of the first times I tried the following method.

The panel was painted completely black first. Then I made a light pencil drawing on the black, and then a kind of paint by numbers approach was followed. Good thing I knew the numbers. (Some artists take themselves far too seriously.)

COLOR PLAN USED HERE

CLOSE VALUES/FREE COLOR

In many parts of the painting, black rims the shapes or becomes a thin shape on its own. The passages of paint are quite thick and opaque over the bulk of the panel. The sky was done with straight Cadmium Yellow Deep at the top, down to the Cadmium Yellow Light at the horizon. The colors in the painting are entirely made up. The values and shapes are very close to how I actually saw them at the time. Keeping the values and shapes closer to reality allows you free reign with color.

Check your emotional response to the color in this painting

What do I like about the color in this painting?

How does this painting speak to me?

What color ideas can I use in my own work?

How would I do it differently?

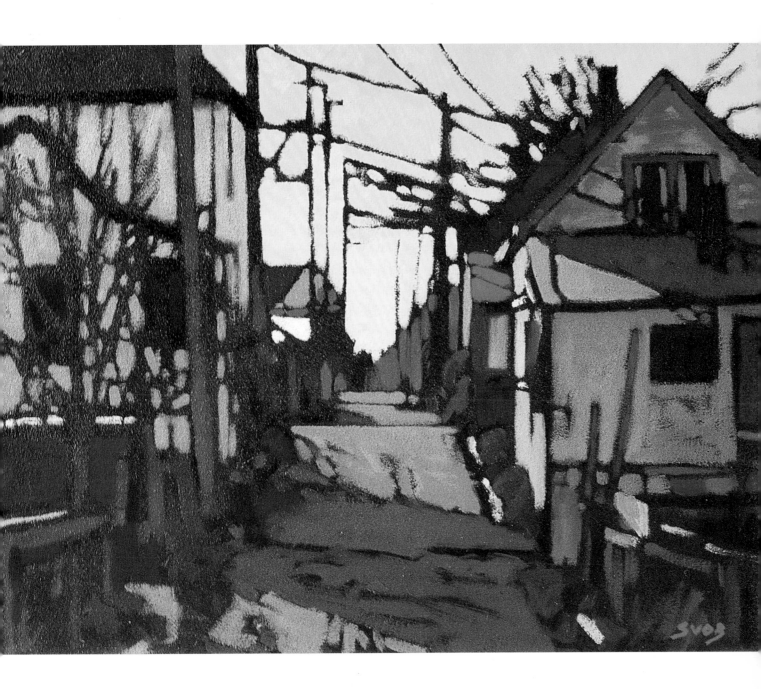

NOTE

If you work from photographs the value of the sky will almost always be too light. The camera reads the sky as the source of light, therefore it almost always reads it as a light value even when it is not.

The more contrast, the greater the attention.

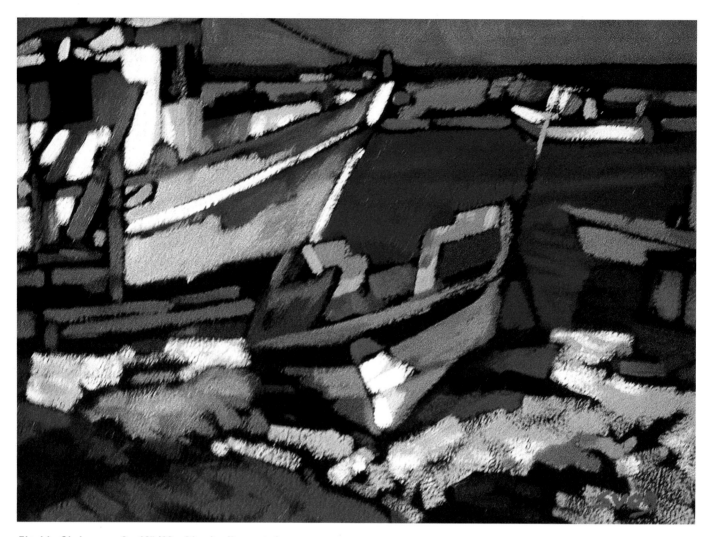

Florida Shrimpers, 9 x 12" (23 x 31cm), oil on panel
The shrimp boats that ply the water in the Gulf of Mexico bear a strong resemblance to the small salmon fishing vessels on the west coast of North America. They make great shapes to paint. Turn to pages 116-117 to see other ways this subject was interpreted.

COLOR PLAN USED HERE

LIGHT-DARK/HIGH KEY-LOW KEY

The technique used here was the same as for the painting "Morning Alley" on page 66. The painting was started on a very dark panel. The next step was to put in a high key color shape and a very light value shape. The white on the larger boat and the blue of the water worked. The painting was then keyed with value from light to dark, and color from high key to low key (black). By keying the values, the range of color and value was established very early on.

 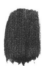

to stay in an igloo in Tuktoyaktuk or Inuvik above the Arctic Circle. The brochures are full of warm, tropical paradise type vacations. **Warm will outdraw cool in almost all walks of life.**

Understand the properties of the paint

There are many properties of pigment, other than color, that can be of interest to an artist. Obviously, the way one pigment blends with others to give yet another color is the most important consideration. As you become more experienced with the actual pigments, other qualities begin to take on importance.

For instance, working with watercolor makes an artist conscious of **transparency**. In watercolor, the artist deliberately uses pigment based on transparency, in addition

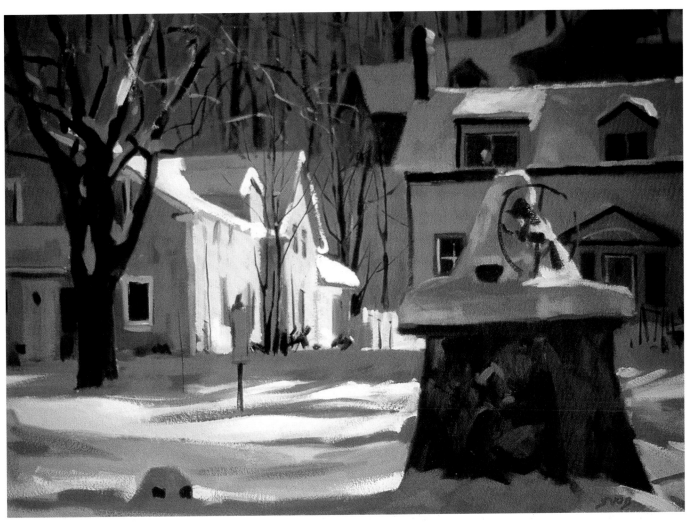

The Old Bell, 18 x 24" (46 x 61cm), oil on panel

to the basic color or hue. **As a general guide, visually transparent passages of paint are more appealing than opaque passages.**

If it is possible, try to **construct your oil painting in a manner that allows as much transparency as possible.** Go back to our test: To check if your paint is transparent or opaque, simply brush out the pigment over a dry, darker value. Does it change the color without markedly changing the value? If the value stays fairly close, the paint in question is more transparent. If it brings the value up noticeably, it is more opaque. Many of the newer Quinacridone and Phthalocyanine pigments are quite transparent. On the other hand, Titanium White and the Cadmium colors are very opaque. The majority of pigments are somewhere in the middle, depending upon the particular brand you use.

COLOR PLAN USED HERE

COOL

The dominant theme here is cool shadows. The blue harmony is a rare one for my taste, but I painted it as I found it. The light was kept warmer than the shadows. To set off the color the shadows area on the house to the right and the monument in front were made a warmer color than they actually appeared.

EXERCISE

Keying a painting for tonal value and color

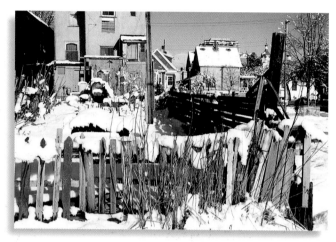

1 Reference Photo

The reference photo contains numerous painting possibilities, but what really drew me to this subject were the snow-covered fences.

2 Thumbnail

To get the graphic language moving in my brain I began by making a thumbnail design. As we know, the thumbnail is where the big design decisions are made. I make sure I feel confident about the thumbnail before committing to paint. That's how you must feel once you've made your thumbnail for this exercise.

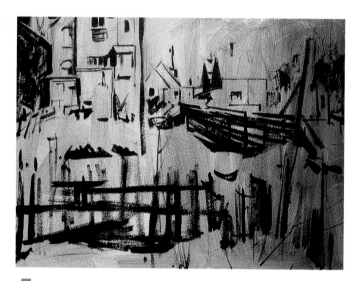

5 Set your first color combination

Before the Transparent Earth Brown is dry, take a clean brush and apply Dioxazine Violet to the right on the white surface. As you continue, blend with the same brush into the brown. The idea is to leave some of the pure color on either side of the panel.

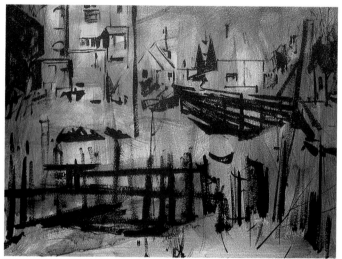

6 Establish the mid value relationships

The first two glazes of the brown and violet are right for color but not for value. The value needs to be a deep mid-tone if the mid values and lighter values are to appear bright. (Often the glazes I use to establish a value relationship at this stage are deeper than appears correct.)

3 Set the dark values

I used a 12 x 16" (31 x 41cm) board but, as before, you can use a canvas board or canvas. Outline the drawing with black gesso and fill in the darkest values. The layout should follow the thumbnail.

4 Make your underpaint glaze

Use a large brush and start a glaze of Transparent Earth Brown on the left. Thin the glaze with a mixture of alkyd and mineral spirits. Allow this to fade out as it moves right. Leave the right side partially white so that the other colors will show better on the white surface.

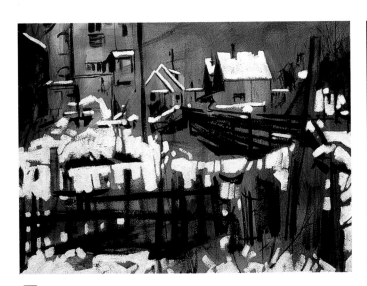

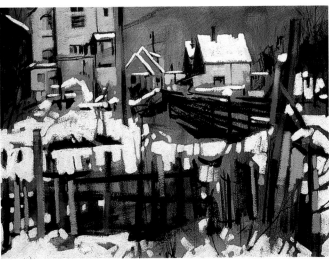

7 Establish the light value areas

Use Titanium White to paint in all the white snow shapes. You can then establish the lightest to darkest values, being careful to paint negative shapes where required around the snow fence. (A negative shape is when you paint around the shape you are trying to create.)

8 Key the color and value

Paint the smaller house in the middle with straight Cadmium Red. The buildings to the left and right can be painted with a high key yellow. The painting is now keyed for color and value. A very important point is to establish the color and tonal value key on your painting before you try to complete it. All your visual judgments about value and color should ultimately be based on the relationship in front of you.

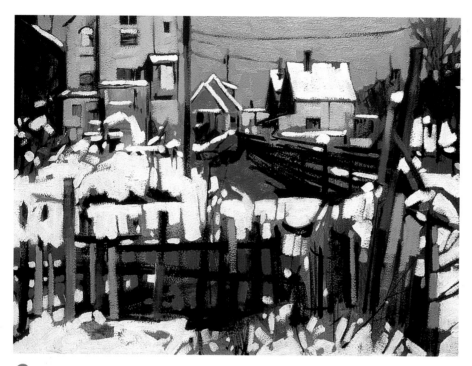

10 **Adjust the values**

You can do some finishing touches around the snow fence to emphasize some of the boards more than others. Touch up a few lighter values in the snow shadows in the middle distance, and it is done. Compare the finished version of "Snow Fence" with the photograph.

9 Now you can play with color to finish off

A very warm green sky and violet snow shadows will give the painting color vibrancy. It's the discord colors that do this. I let my color sensibility tell me what color something should ultimately be. I mix it up on the palette and stick one brushstroke on the painting where it is meant to go. If I like the color relationship when I see it on the painting I go with it, period.

Compare the finished painting shown in mono with my first value statement and my tonal value sketch

I let my color sensibility tell me what color something should ultimately be. I mix it up on the palette and stick one brushstroke on the painting where it is meant to go. If I like the color relationship when I see it on the painting I go with it, period.

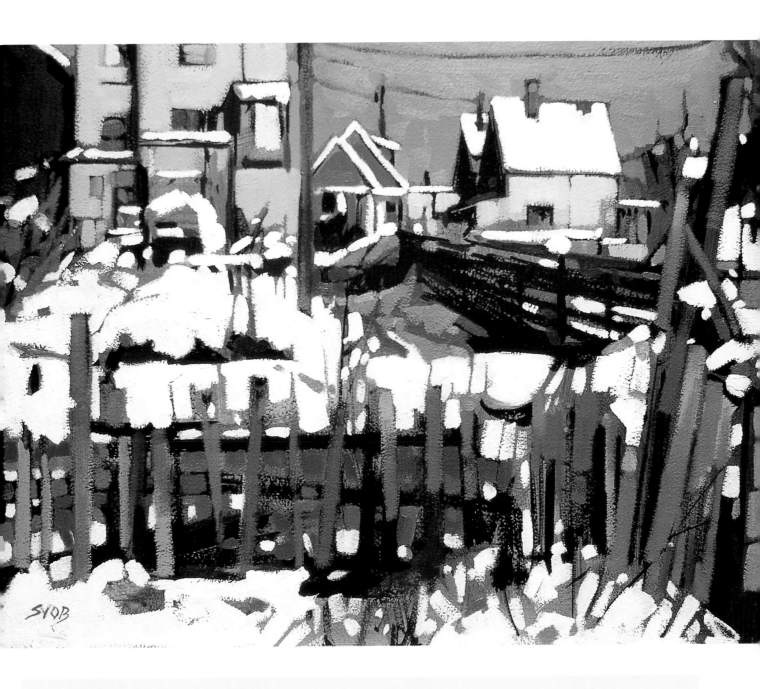

SVOB

SELF EVALUATION

How did you handle this exercise?

What did you find most difficult?

What did you find easy?

Do you understand the concept of keying the tonal values and the colors?

Were you able to identify the different color temperatures?

Do you understand what a negative shape is?

Will you always be aware of places to use transparent color and places to use opaque color from now on?

PAINTING "MUST HAVE" LANDSCAPES

Turning buyers on by understanding how they see.

It is amazing the way some people can become attracted to the point of distraction over a little bit of pigment spread thinly on canvas. The reasons for this attraction are as varied and numerous as the proverbial grains of sand in the desert.

In our age there is great latitude in acceptable taste and this leads to greater **freedom in artistic design and expression.** In many respects people can buy, or be sold, just about anything as a work of art. This is the reality of our time. There are arguments for and against particular styles of artistic expression being more or less legitimate. Don't worry. Be happy. There is room for all of us.

In ancient times, the number of people who could afford to decorate their walls was very limited. To make a living as an artist you had to "work for the Man", be he pope, king, duke or caesar. The range of artistic

A Reflective Moment, 30 x 40" (76 x 102 cm), oil on canvas
Lighthouse Park on the ocean at West Vancouver is a popular spot for swimming. The shimmering light on the water and the beautifully colored granite rock makes it a great place to find creative inspiration. In this painting the figures give the scene scale and humanity. However, they never did jump into the water. The cold North Pacific current flows in here, so you need a bit of courage to take the plunge.

The drawing was carefully laid out with a light value of Transparent Earth Red. The water was painted in with cool transparent mixtures, and was overpainted with opaque, lighter tonal values for the highlights. The rocks were handled in a similar manner with warmer mixtures.

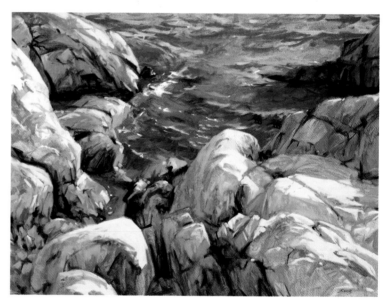

What happens if we take the figures out of this scene?

Which of these paintings do you think a potential buyer would prefer to take home? The addition of believable figures participating actively in the landscape environment has a special attraction to us as human beings. The psychology of this obviously goes very deep. Knowing this can help you make a sale.

When you include figures in your work, make sure they don't look "stuck on". They should blend in and have the same lighting and shadows that are applied to the landscape surrounding them.

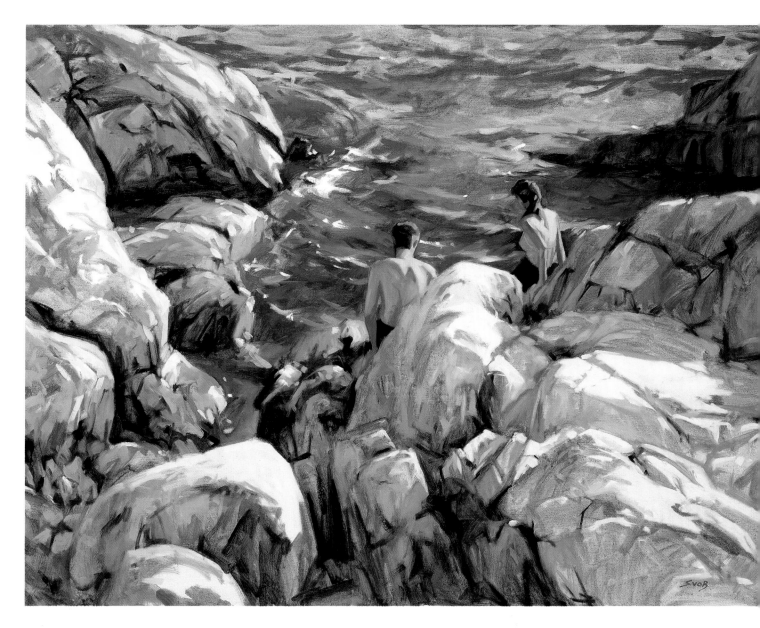

license was also very limited. Today there are many people with a firm sense of their own self and they have the means to support their personal indulgences. The result is that numerous styles of art can be pursued simultaneously. The fact that you are reading this book most likely means you support and are interested in the direction of the art shown here.

This variety of taste matters to the aspiring artist because it allows much greater freedom to go off and explore their own unique painting style, and still earn a living by selling their work. Picasso was one of the notable

artists to really make great use of this freedom. The nice thing is that even those artists who hate so-called modern contemporary, or conceptual, art can still practice their unique brand of art — a much more difficult thing to do when the pope was the only game in town. **The freedom we have today allows artists to find an audience for their own message much more easily, no matter what their style.**

Finding your own way in painting and discovering you have something to say that appeals to others is what the artistic journey is all about.

Color is my message

In my landscape paintings I try to retain a sense of reality with an obtuse twist by pushing color. Color is where I take the greatest liberty. Color is my message. It's pretty straightforward when you put it this way, but there it is. Sounds simple. However, I weave that color into a composition and design filled with other graphic elements. The enjoyment and challenge is to sort shapes, tonal values, edges and color into a coherent message. To do this I must understand and make use of the way viewers see, or read, a painting.

Continued on page 81

What made these paintings bestsellers?

White Rock Hillside, 12 x 16" (31 x 41cm), oil on board

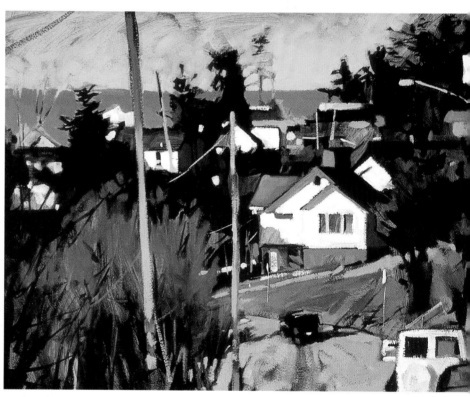

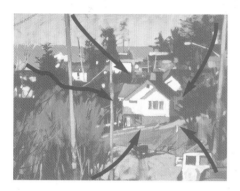

The Eye-Path Plan

What's the message? And how did I lead the viewer's eye?

The dark patterns in the roofs and trees create the deep tonal values for the contrasting light tonal value shapes. Notice how the pole on the left goes from darker against a lighter sky, to lighter against a darker background in the lower area of the painting. This is a graphic device I often use to tie different parts of a painting together. The larger vehicles in the lower right combine with the smaller middle distant black vehicle to give scale and perspective to the painting.

Understanding the way we see is critical to understanding how others will read your composition. The way we see is part of the human condition and common to all cultures and people.

What the eye sees first

The visual artist needs to pay most attention to the fact that the eye is drawn first to the greatest contrast in any painting. The graphic elements in the composition act to move the eye through that composition based on the amount of **visual contrast** in any part of that painting. The areas of lower contrast draw less attention, with the eye tending to move on to the next point of contrast quickly. This is the essence of how we move the viewer through our composition.

Know what turns you on

To inspire and turn a viewer on, and then hold their attention, a painting should have a strong message, or point of view. **The artist must have a vision or plan from the start. The artist should be turned on to one or more graphic elements they hope to emphasize in their work.** Before any marks are made, I ask what gets me excited about the subject. I pinpoint the graphic elements that will be dominant and the ones that will be subordinate? I ask if it is the shapes that turn me on? The color? The lighting? The values? I make sure my answer is something I can paint.

The reality is that you cannot paint the human figure or a tree in a landscape. You cannot paint an idea like "beautiful". You can

YOU HAVEN'T USED CONTRAST TO LEAD THEIR EYES

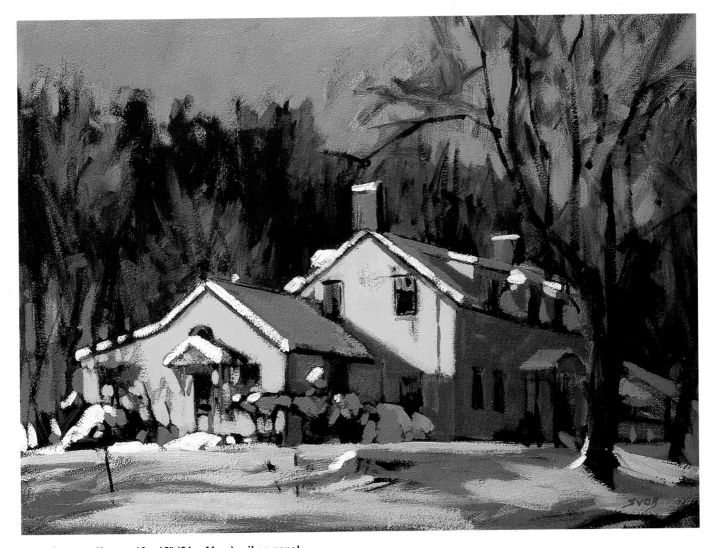

19th Century House, 12 x 16" (31 x 41cm), oil on panel

What's the message?
And how did I lead the viewer's eye?

The house depicted here is probably 150 years old. In Canada that makes it most unusual.

The subject is a romantic, nostalgic scene from a time that has passed. However, I painted it for its brilliant yellow color against the backdrop of rich warm trees, not for its nostalgic value.

Brilliant Contrast

What made these paintings bestsellers?

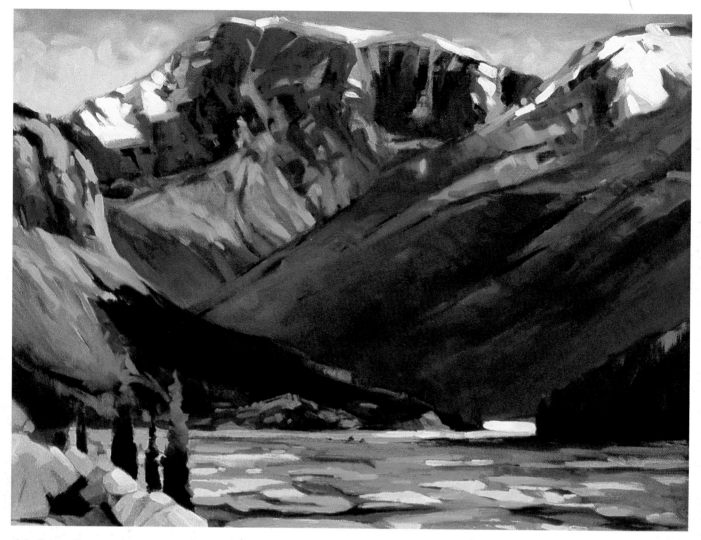

Athabasca Country, 18 x 24" (46 x 61cm), oil on canvas

What's the message?
And how did I lead the viewer's eye?

The Athabasca River begins its long journey to the Arctic Ocean near this point. The mountains tower over the river's out-wash plain, which is carpeted with alpine flowers during the short growing season available at this altitude.

To give the mountains as much size and majesty as possible I gave the painting a very high horizon. The small foreground trees and the rocks in the lower left add to the scale.

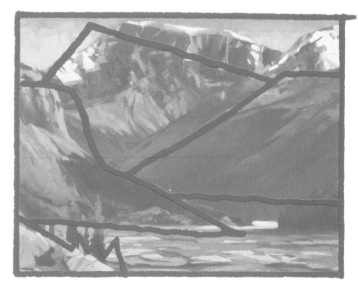

Interlocking Shapes

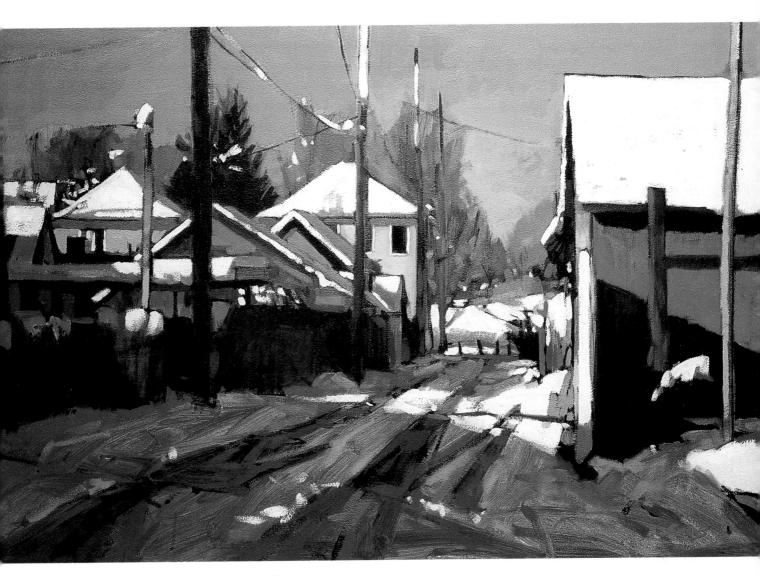

Strathcona Park, 16 x 24" (41 x 61cm), oil on panel

What's the message?
And how did I lead the viewer's eye?

The back alleys of Vancouver have been the source of many of my paintings in recent years. I find the random nature of the buildings and their locations unusual. It is the opposite of neat and tidy.

The very warm green sky in the painting complements the deep reds on some of the buildings. I did not know what color the sky was going to be until I began to put a few brushstrokes of paint there. I tried a few different colors but settled on this green. I always leave the decision about what will work for me until the paint is on the canvas. Then I make a final judgment.

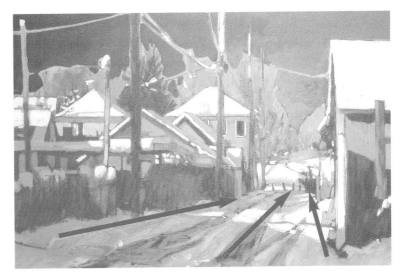

The Eye-Path Plan

What made these paintings bestsellers?

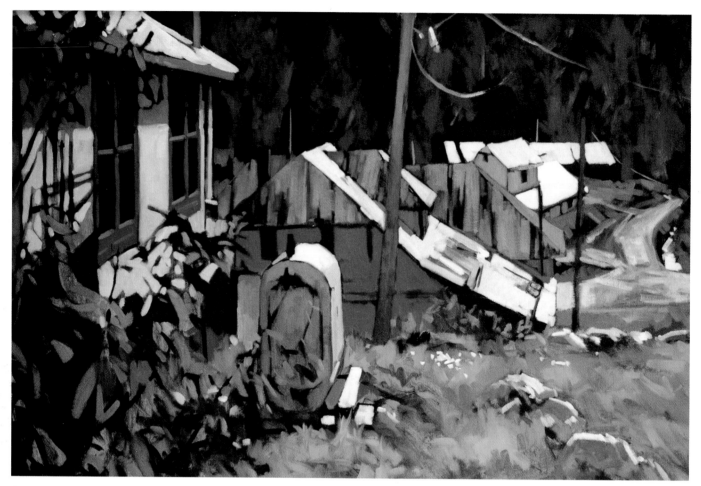

Tin Roofs, 20 x 30" (51 x 76cm), oil on canvas

What's the message?
And how did I lead the viewer's eye?

The stark contrast of the tin roofs against the dark background is what attracted me to this scene. Brilliant contrast is another element that keeps repeating in my paintings. The effect of intense light draws most artists at one time or another. To achieve contrast such as this it is essential to have a full range of tonal values from the lightest to the darkest.

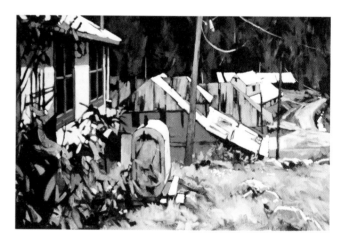

Brilliant Contrast

Finding your own way in painting and discovering that others identify with what you have to say is what the artistic journey is all about.

Continued from page 75
only paint the shapes, tonal values and colors that, seen together, create the illusion of a figure or a tree. You cannot paint an old person or a young person. If you are trying to create the illusion of being old as opposed to young you must identify and convey those graphic elements that create the illusion of youth or old age. The artist needs to pay close attention to these graphic elements.

Explore the idea with multiple studies

A common method used by artists, myself included, is to explore a subject's characteristics and compositional possibilities by making different versions of the same subject. The use of **multiple studies** lets the artist more deeply explore the possibilities. Monet did this to a great extent. He made a series of small paintings depicting haystacks in various light and colors. He then made a series of larger paintings of the same haystacks in differing light and colors again. I bet Monet knew what turned him on about haystacks by the time he finished the series.

Exploring a subject thoroughly will give you **greater insight into the possibilities and drawbacks** of painting that subject. When other people see your work, notice their reactions. They will see things in your paintings you may never have noticed. They will invariably find greater appeal in one version than another. Ask them why? Do you agree with their perspective? It does not really matter whose opinion you get, just that you do get another person's perspective. Remember, painting is communicating, first to yourself and then to others.

Show and share

There is an additional benefit in showing and sharing your work that will have an impact on your long term development as an artist. You will find people who like what you are doing. This acceptance is positive reinforcement and it will be a great source of energy for your

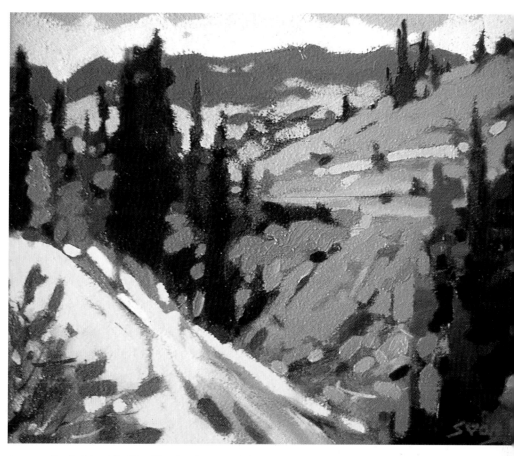

Lassen Park, 11 x 14" (28 x 36cm), oil on panel
This painting began as a faithful depiction of Lassen park that went awry.
In the final version you see here, very little of the original remains. On occasion, as in this painting, when things go wrong, I will set myself some design parameters to try and rescue it. Almost invariably the exercise involves simplifying the statements I am trying to make.
Getting caught up in too much detail is a trap which is too easily fallen into.

future artistic endeavors. All the positive reinforcement you receive will make you bolder and braver in your artistic approach.

The first time I turned a blue sky into an orange sky I was not sure if I liked it. I thought it looked good but was doubtful. When I showed the painting, the reaction was emphatic, either thumbs-up or thumbs-down. My immediate reaction was to tell myself that the thumbs-down crowd were artistic neanderthals and the thumbs-up crowd were obviously endowed with the ability to recognize creative genius when they saw it. Well, maybe not genius, but at least they bought it and it allowed me to set off and continue my artistic explorations.

The point is, artists need positive reinforcement when they are searching for their direction. I believe that if you keep showing your work there are people out there, somewhere, who will recognize your brand of artistic genius. You will find comfort and receive support from them, no matter what direction you take.

What made these paintings bestsellers?

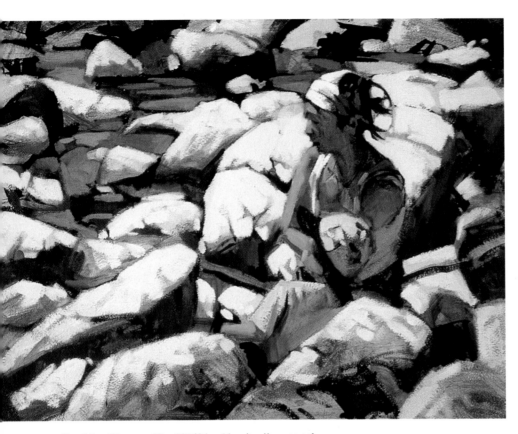

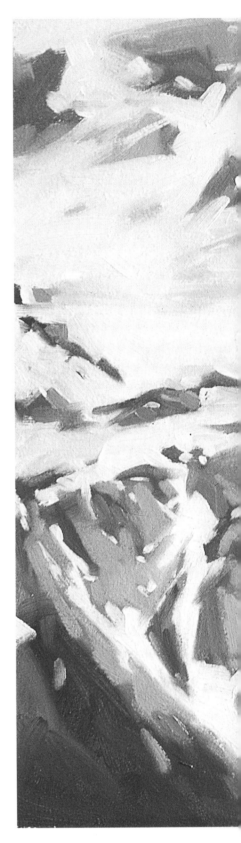

Boulder Strewn, 12 x 16" (31 x 41cm), oil on panel

A boulder strewn stretch of the Shannon River below Shannon Falls was the setting for this painting. I snapped a photo of these two catching some sunshine and painted the scene in my studio.

The painting design breaks a whole bunch of composition guides. There are too many areas of strong contrast and similar monotonous shapes. I think the appeal lies in the almost camouflage effect the painting has. On first take, most people do not notice the figures.

The freedom we have today allows artists to find an audience for their own message much more easily, no matter what their style.

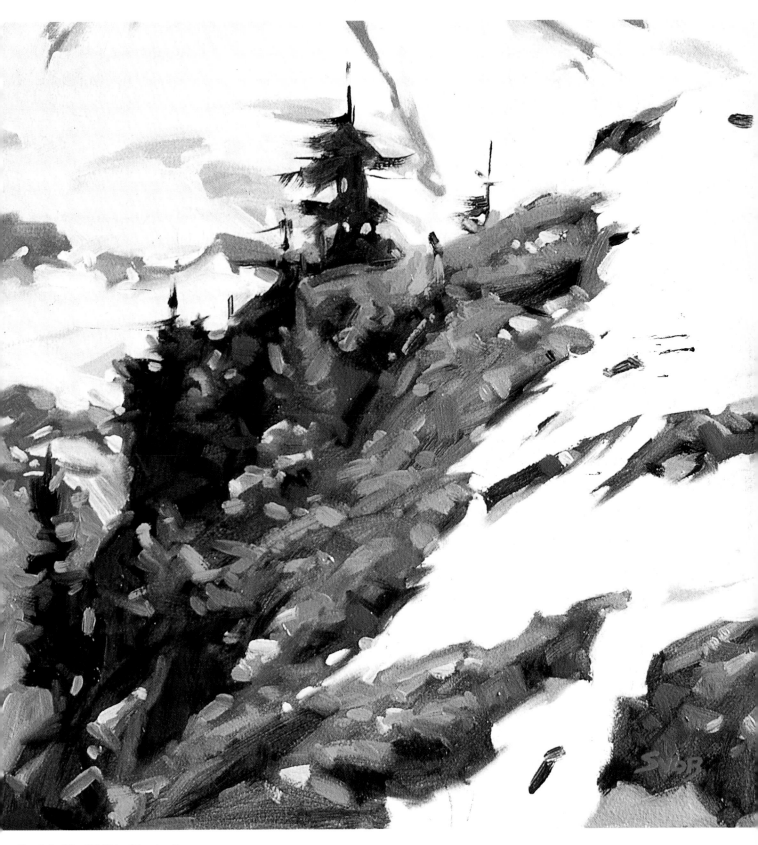

Nuntak, 12 x 16" (31 x 41cm), oil on canvas

It is amazing the way plants can cling to rocks in the most inhospitable places and still somehow survive. This picture depicts midsummer on Mount Baker. A place that recently received over 100 feet or 30 metres of snow in one season.

This painting is a faithful version of the scene. The sense of atmosphere and depth was reinforced by making the objects in the distance cooler or bluer, and with less tonal value contrast than the objects in the foreground.

EXERCISE

Reality with a twist

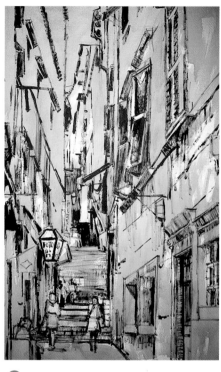

1 Turning yourself on with the thumbnail sketch

The thumbnail sketch is the really creative part where you can make any major changes to the composition. Because the scale is so small the tonal values and shapes can be kept simple and the detail eliminated. These sketches should be no more than a few inches in size and have no more than a basic tonal value pattern.

The act of making the thumbnail takes you from thinking abstractly to actually executing and seeing what will happen. While making the thumbnail you can think about the problems you may encounter, or the techniques you may use in completing the painting. The thumbnail has to be exciting enough to turn you on before you go to the painting stage.

2 Make a loose drawing

After making sure the canvas selected matches the basic dimensions of the thumbnail, begin with a black gesso line drawing. Remember that black gesso gives the full value range possible right from the start. Gesso also dries quickly and provides a consistent surface quality for the following glazes.

Keep the drawing fairly loose and only indicate the basic shapes. In some places the black gesso line will show through in the final piece. This is okay.

3 Apply your dominant color glaze

In this step choose a dominant color and begin glazing over the painting with thin, transparent, warm colors. Leave some areas white so that you can come in with some cooler glazes later. (A similar result could be achieved by starting with a warm, earth toned canvas rather than the black drawing.)

Add the two figures on the lower stairs to draw interest to that area of the painting.

4 Introduce darker tonal values and warmer color temperature

Continue glazing with Dioxazine Violet to achieve some deeper values and cooler color, especially in the shadow areas. By now the entire canvas should be covered with paint. This ensures you will be able to paint in some lighter value areas where you feel they help the design most. The rich color harmony just glows as the violet and earth tones play off each other. Try to save as much of this effect as possible in the final painting.

5 Make corrections

After finishing the transparent glazes and allowing them to dry sufficiently you can now paint opaque or transparent color anywhere on the canvas. The actual amount of time involved to this point should not be that great compared with the time involved in finishing the piece.

At this stage, if you look at the upper portion of the buildings on the left and in the middle distance they appear bluer or cooler than in the finished work. I thought the color contrast drew too much attention. To correct this I made the buildings closer in color temperature to the sky. I am told my special talent (if indeed I have one) is in color. I guess this is an example of my color sense taking over. In my judgment I simply make choices that agree with my sensibilities.

Work on the painting from the top down being careful to not overly finish any area of the design. Try to save the greatest finish or detail for the final stage. This is done so that you can control the viewer's eye as it moves around the painting from the areas of greatest contrast and detail to the lesser ones.

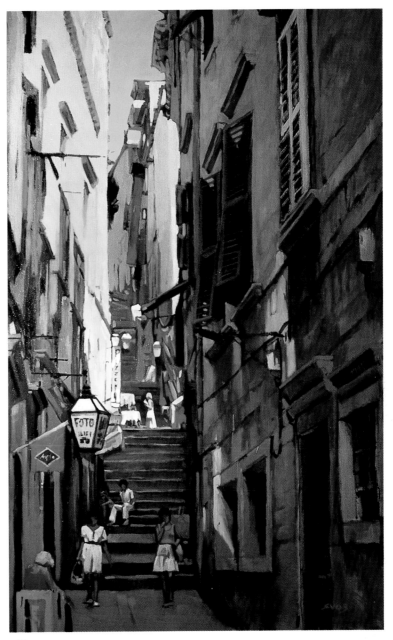

6 Enhance the contrast to lead the eye

Finish "Old World Charm" by bringing out enough color and tonal value contrast in the areas of the piece that you think will make the most pleasing design. For instance, I used Cadmium Red to make the flag and distant banner prominent and eye-catching.

Bring the figures in the foreground and on the stairs to a greater degree of reality with detail and added tonal value contrast. The building on the right should be given a similar treatment to help push the middle and distant areas back into the picture plane. The final touch is the lantern with FOTO printed on it. The lettering brings it into focus and draws the viewer's eye directly.

SELF EVALUATION

How did you handle this exercise?

What did you find most difficult?

What did you find easy?

Do you understand the concept of leading the eye using contrast?

Were you able to identify the different tonal values?

Did you understand how I modified the color in stage 5?

Will you always think about contrast as a design tool from now on?

EDGES — THE MAKE OR BREAK PART O

Communicating your vision with subtle nuances and deliberate strokes.

Every stroke of the loaded brush leaves behind color, tonal value and an edge. The edge is the **transition** from one color shape or tonal value shape to the next. We need to be able to see, measure and paint with control all three of these graphic elements to effectively create art. Edges are often the poor cousin in this triumvirate, rarely taken seriously by some, and completely ignored by others. Edges should not be ignored. If you treat them seriously when you design and paint you will be rewarded with a more professional work. Using **various edges gives you more nuance and control over the viewer's attention** than can otherwise be obtained. From the softest, slowest transition to the hardest, razor sharp edge that draws your eye, painting edges requires practice and attention.

Identify the patterns and the edges

To paint the correct transition from one shape to the next you must be able to **measure** that change. When painting edges we must simplify, just as we simplify shapes and tonal values. **Squinting** helps to simplify all these elements. With a bit of practice you will learn to see both the broad tonal value pattern and the simple edges by squinting. The hardest edges are the last to disappear as we squint our eyes tighter and tighter. The softest or most gradual changes disappear first.

Don't just take my word for it. Try squinting at your subject. As I said right at the beginning of this book, squinting should become a habit.

Our eyes can discern far more edges than are needed in any painting. The longer we focus on the same subject the greater the detail, and the more edges we will see. The same thing happens with tonal value. The longer we look, the more detail we see. This detail is often the exact opposite of what you want in your designs. You will want to simplify and control where the viewer perceives detail in a design.

Simplify the edges and narrow the tonal value changes as you move away from the center of interest. This makes your design easier for the viewer to read. You will actually confuse your audience by providing too much information.

In practice, I do not always paint the edge I see. If I feel that the composition warrants a change, I will make it. In fact, **I will change any graphic element if I think it will create a more interesting design.** When I am not sure it will improve the design, I paint the edge or tonal value or color that I see.

Edges lead the eye

Edges can be used as a graphic device to move the viewer through your design. The

December Lake Louise,
22 x 28" (56 x 71cm), oil on canvas
This version of Lake Louise in its winter finery depicted here is very close to a tonal or value study. Color contrast has been kept to a mimimum. The painting is about shapes and edges. The softest transitions, such as in the clouds, were painted wet-into-wet. The harder edges of the lower dark area of the mountains were painted into the dark value shapes which had already dried tacky. The result is a faithful depiction of the day.

Controlling The Buyer's Attention

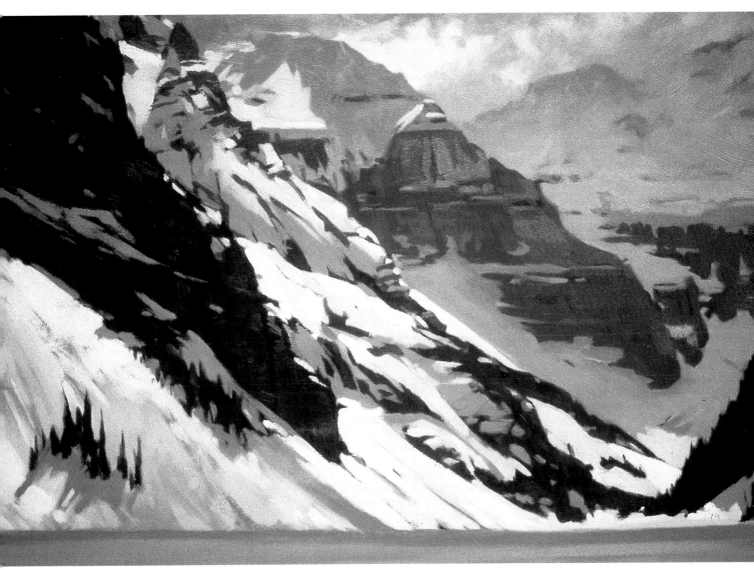

THE EDGE PLAN

The edges that required extra attention here were in the water and the shadows on a patch of snow in the upper right. It was essential that these transitions be very soft.

How I Control Edges

I control my edges with a fairly typical oil painting technique — but with a few twists.

1 *I begin most of my paintings by drawing in with black gesso. I outline the larger shapes and fill in the darkest tonal values. In places I will use a dry brush, broken color technique to provide texture, to cover dark mid-tone areas or to create broken edges.*

2 *When the gesso has dried I begin to lay in large, transparent passages over the entire canvas. The edges are all kept very soft in this second step.*

3 *The third stage in the painting of edges may begin quickly when I want to softly blend into the underpainting. I make harder edges later on when the underpainting has begun to dry, yet remains tacky. The general practice is to paint soft edges first and hard edges last.*

Proceeding in this manner is the best way to do it because it keeps the hardest, most eye-catching edge in reserve until you are absolutely sure where you want the contrast. It's the same idea as saving highlights to the end.

hardest edge, with the most contrast, can be used at or near the center of interest, or it can be combined with tonal value and color contrast to draw even more attention. Beware of the compositional problem that arises when you put too much interest in one place. Your design will become too obvious and therefore boring. Your composition should have nuance by providing differing points of contrast. Some areas of contrast should be more obvious and they should draw the eye, other areas should be less obvious. Your control of edges is a useful way to move the viewer's eye around your painting.

Achieving different edges

Once you know how to measure and compare edges, and you have an idea of how they affect your design, you will be able to paint the type of edges you want, where and when you want them.

When it comes to control of edges, oil paint is the medium of choice. All the other painting mediums come up short when compared to the working time or degree of control that can be achieved with oil paint. Oil paint can be thinned with a solvent such as turpentine or mineral spirits to provide a **wash** similar to watercolor. Oil paint can be combined with stand oil or alkyd to create a wonderfully consistent **glaze**, similar to acrylic. **Dry brush** effects can be achieved by painting over dried paint, similar to the way a pastel artist would work with broken color. The real charm for most oil painters though is to be able to paint **wet-into-wet** and manipulate the edges at leisure. If you paint an edge, shape, or tonal value that you are not satisfied with, simply use a painting knife, brush or rag to remove the paint or alter the edge.

MAKE OR BREAK EDGES

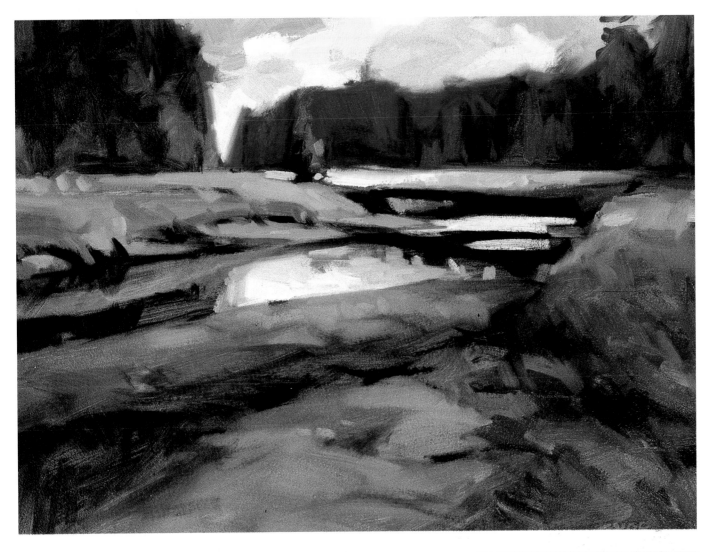

Estuary (Haida Gwaii),
12 x 16" (31 x 41cm),
oil on panel
A two-week painting adventure to the Queen Charlotte Islands resulted in this tranquil river scene as well as a few others. The design elements all come together here in a simple, yet elegant symmetry.

THE EDGE PLAN

The hardest edge and greatest tonal value contrast occur around the small tree and along the riverbank in the upper center of the painting. Away from this area edges are softer and the shapes are simplified.

**East of Yellowstone,
12 x 16" (31 x 41cm), oil on panel**
The mountains east of the continental divide receive very little rain because of the rain shadow effect, and are mostly grass covered as a result.

The grass had already turned a golden color by August. The effect was to soften and scatter the late daylight creating a very rounded and slowly changing tonal value as the mountains curved away from the light. The method used to capture the effect was to paint each tonal value change wet-into-wet.

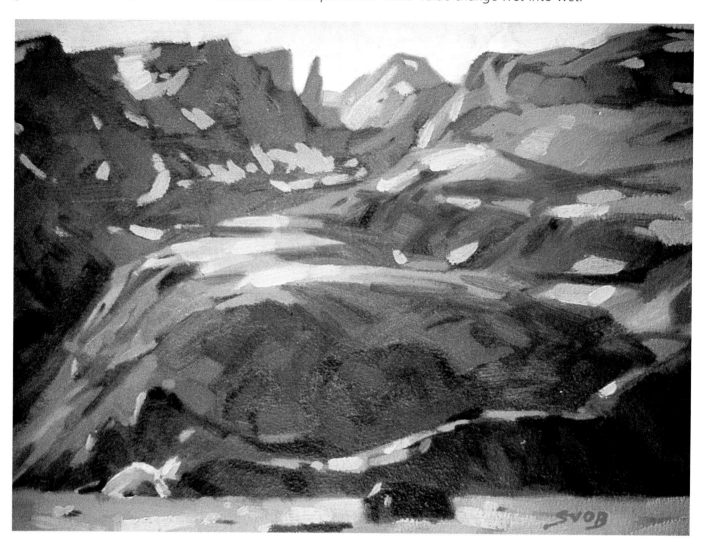

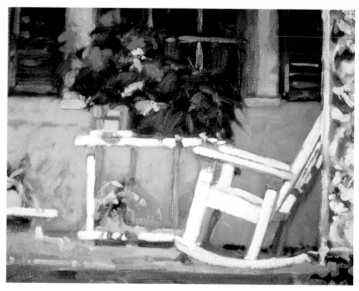

*__Southern Rocker__, 12 x 16" (31 x 41cm), oil on panel
The inspiration for this painting was the white rocker against the deep yellow of the wall.*

THE EDGE PLAN

I included this painting because of the range of edges it contains, even though it is not a landscape. A full complement of edges and techniques was used, from the lost and found area around the plants and window, to the hardest edge on the rocker, wet-into-wet on the floor, lifting on the yellow wall and dry brush on the ornamental railing.

Frozen Vermilion,
12 x 16" (31 x 41cm), oil on panel
The frozen shoreline of Vermilion Lake, with the snow covered fallen spruce provide the horizontal elements in this design. The standing trees provide a contrasting vertical element.

THE EDGE PLAN

The upper portion of the painting down to the lake shore was done wet-in-wet. I continued the wet-in-wet technique over the entire lower portion for the snow and orange bushes. The dark trees and details were painted over the top of this when the underpainting had dried sufficiently so that the paint would not mix in.

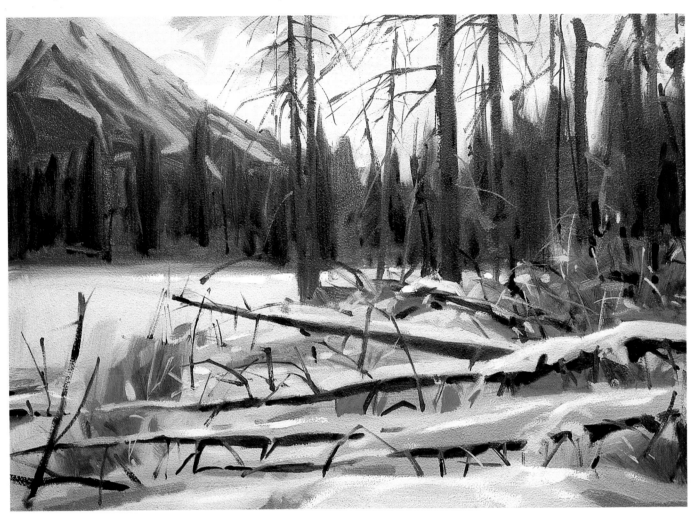

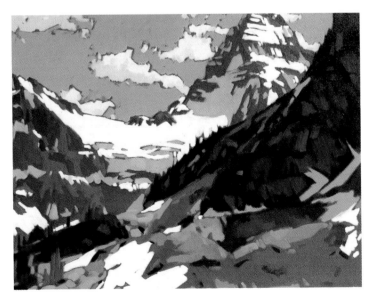

Sunburst Lake, 16 x 20" (41 x 51cm), oil on panel

THE EDGE PLAN

It was time for a change in approach. The panel was painted with Cadmium Red that was allowed to show through around the edges of most shapes. The resulting red edge provides a color transition from one shape to the next. The effect is an unusual kind of harmony throughout the painting.

DIFFERENT EDGES, SAME SCENE

The Hard Edge Version

What's the difference?

Compare the first **Hard Edge** version with the second **Soft Edge** version.
What effect do the edges have on the look of the painting?

 If your answer is that the softer edge version has a more realistic, atmospheric look, then you will be right. The harder edge version is more symbolic and graphic.

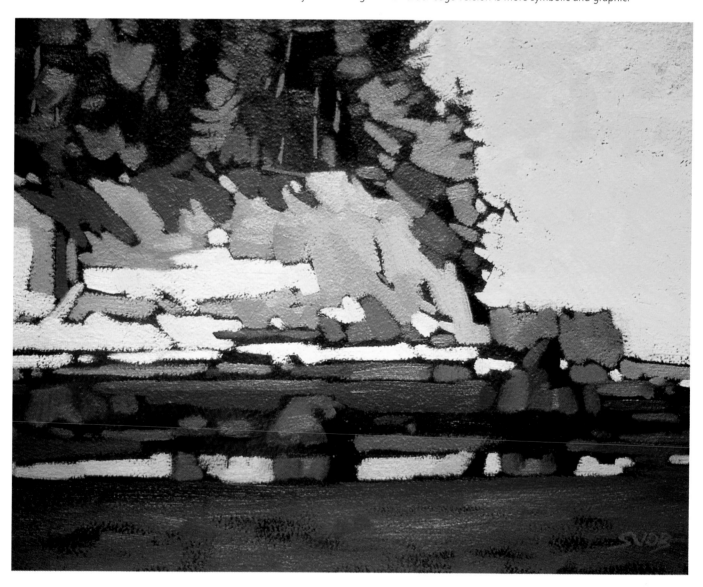

The Soft Edge Version

A good way to develop your abilities and challenge yourself is to try different exercises such as these **hard edge** versus **soft edge** versions of my painting **"Savary Island Shore"**.

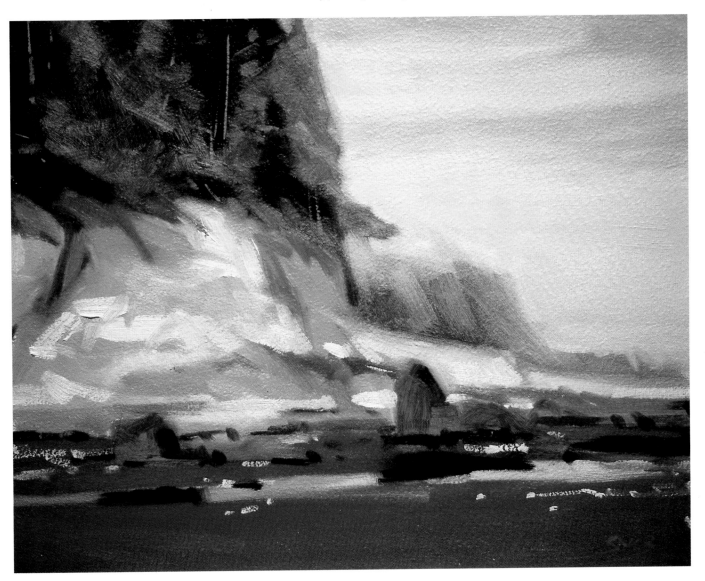

EXERCISE

Different edges, same scene

THE HARD EDGE VERSION

When painting, begin with your largest lightest tonal value shape. Use the paint as it comes out of the tube, no mediums. Paint application should be thick and direct — no reworking the paint to fill in. Allow the broken edge of each brushstroke to show around the edge of the tonal value shape. Proceed in this

1 Prepare the support

Choose a panel, canvas board or canvas. Make a pencil drawing of the scene then cover the support with a dark tonal value mixture of Cadmium Red and Ivory Black. Your pencil outline should still be visible and this will help you identify the shapes.

2 Paint the dark panel as follows

Paint the large light tonal value first — in this case the Cadmium Yellow sky. Painting the lightest value first helps establish a tonal value scale. Brush in a few of the darkest tonal values to reinforce the tonal value range. Use a mixture of Ultramarine Blue and Titanium White for the shadow areas under the trees to give a vibrant color range. The painting now has a tonal value key and a color key.

3 Work from the big shapes to the small ones

The painting can be completed in any order now. The method I like to use is to work from the biggest, most obvious shapes to the smallest.

4 Pay attention to tonal values

Brush in the shapes on the beach being careful to leave the toned surface wherever the tonal value is similar to the tonal value in the subject.

manner to fill in each shape leaving only a thin line of the underpainting to separate each tonal value or color. You do need to be patient, but not necessarily fussy.

After painting in your light value shapes, proceed in the same manner to do one of the mid value shapes. Pick one

that is easy to see and paint. Once you have this step done you have a tonal value key on your painting right where you need it. From here on in just continue wherever you want to go next. Simple, don't you think?

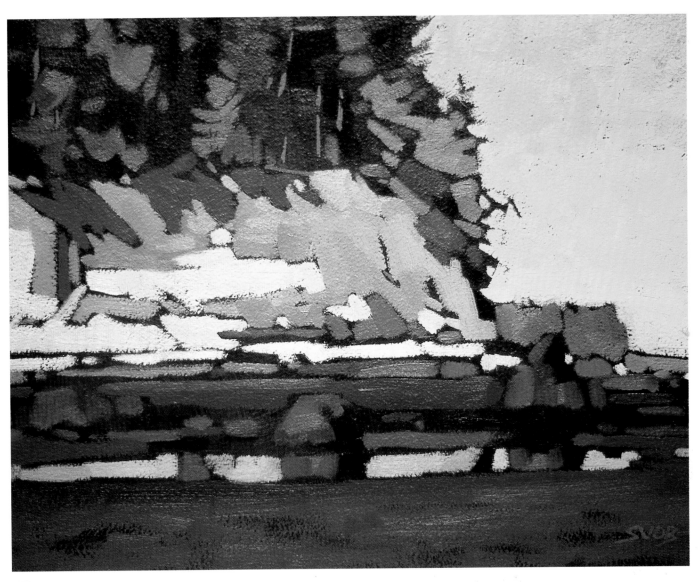

5 Finish off

To finish, paint in the smaller shapes and clean up some of the larger shapes. Brush in the thin tree trunk shapes using a small watercolor type brush and thinned paint.

If you follow what I did the result will be a Hard Edge version of Savary Island Shore.

Keep your hardest, most eye-catching edge in reserve until you are absolutely sure where you want to make the contrast.

EXERCISE

Different edges, same scene

THE SOFT-EDGE VERSION

Begin with the largest darkest tonal value shapes. Use the paint as it comes out of the tube, no mediums. Fill in the shapes completely taking care to leave no specks of white showing through. Brush in all your shapes in their respective and color. Do not overlap your shapes. Butt edge your shapes together. It is not necessary to be precise. For this version use a white support.

1 Establish the large shapes
Paint all the larger shapes and butt their edges up against each other. Ignore smaller shapes that can be painted over the top later.

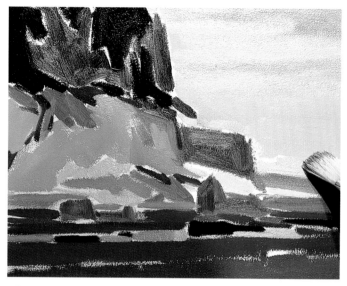

2 Blend the edges
Take a clean and dry brush and begin blending edges. It is essential to clean and dry your brush often. Try larger and smaller brushes to see what effect you achieve. Stiff oil painting brushes tend to remove paint as well as blend. Try blending with the direction of the edge for a more rapid change. Blend at right angles for a softer change. In the picture here I am blending in a horizontal direction with the shape of the edges.

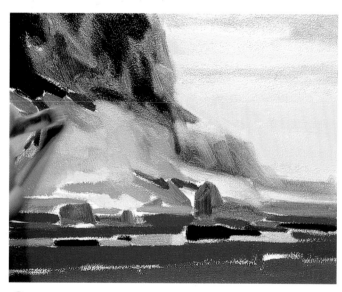

3 Continue blending
Next, blend the shapes in the upper portion of the cliff, rocks and trees together. After that, blend the shapes at the bottom of the cliff.

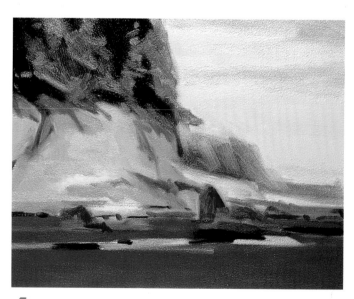

4 Introduce the smaller shapes
Once all the edges have been softened you can paint the smaller shapes on top.

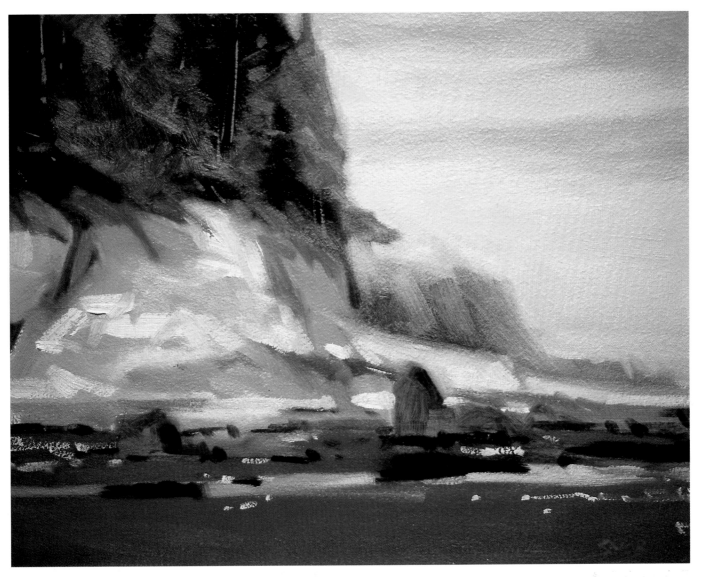

5 Finish off
Suggest a few stones on the beach, introduce a light area on the cliff and tree trunks in the forest, and it is done.

Think about the different results you achieved by using an underpainted support, and then a white support

Which did you prefer?

ASSIGNMENT TRY ANOTHER HARD EDGE/SOFT EDGE PAINTING. YOU WILL BE SURPRISED AND PLEASED WITH YOUR RESULTS

To start, find a good reference photo or slide. An image you want to paint, that has tonal value changes and shapes you can clearly see, is a good place to begin.

Make a three-value thumbnail to get it organized and composed, just as we have been doing throughout this book.

Choose two supports. I suggest you keep the size small, maybe 9 x 12" or 11 x 14" (31 x 41cm or 28 x 36cm). Prepare one panel, board or canvas beforehand with a dark value — a mixture of Cadmium Red and black works well as in the Hard Edge exercise we just did. Keep the other

panel white.

Make a tonal value thumbnail from the photograph and once you are satisfied with it, make a simple outline sketch on both of your supports. Then proceed as we did in the previous exercises.

MAKING IT LOOK GREAT ON THE

The glare caused by gallery lighting is your enemy. Here's how to boost your sales appeal by using texture and varnish.

Preparing a support and ground then fussing over surface finish is rather dry stuff to explain, but it does have a big impact on getting a high visual quality into your pictures. Experimenting with different grounds and supports will help you open up new opportunities in your painting techniques. It may be just what you need to get those creative juices flowing. **Creative artists are consummate problem solvers.** At the very least, by trying to work your normal painting practice on a different ground you will yield a new result. It could even pull you out of an artistic rut. Whenever I begin to feel a bit bored with my painting technique I will throw something new into the mix, such as a new surface.

Over the past two decades of painting I have worked on cinder block, brick, stucco (from smooth to rough), plaster, cement, wood panel, plywood, wood plank, every conceivable type of paper and dozens of different types of canvas and linen, and even different types of silk.

All of these supports were prepared with a suitable ground for painting. Many of these painting supports are not permanent, but that is not the reason for their use. **The result of painting on all these different supports and grounds is greater freedom of expression and a wider range of techniques.** Some of the techniques I use for solving the problems of working on rough stucco, for example, transfer to my approach

on a normal canvas. It is virtually impossible to paint directly onto a very rough surface like stucco with control and still fill in those pesky holes and cracks. The solution is to wash the surface with a thinned, free flowing mixture. Over this it is necessary to learn to use broken color, there is no other choice. After making several large-scale works in this manner I find working on a smaller canvas in glazes and dry brush is much more fun, and easier. I approach it with more **confidence**. Knowledge gained in a different medium or working on a different support or ground can, and will, push your artwork in new directions.

What is a ground?

The ground is the primer, gesso or other paint application that prepares the support for the oil paint on top. The ground I currently prefer is an acrylic chalk gesso, one of the common artist quality gessoes available today. The other is an acrylic Titanium White gesso. This surface is slicker or more slippery in comparison with the chalk-based gesso. The main reason for using one of the artist quality gessoes is **permanence**. The gessoed ground is brilliant white and neutral pH. The surface is very **stable** and will not affect the paint layers applied on top, either short term or long term. On occasion I begin my paintings on colored gesso grounds, such as black or red. This is mostly for convenience. A thin layer of red or

black oil or acrylic paint will yield the same result.

The texture of the ground under the actual oil paint film can be altered to achieve different effects. As we saw earlier, in cases where a thick gesso is applied with a brush the resultant brush marks remain in the gesso but appear to the viewer to be part of the oil paint application. Molding paste, acrylic gel or other heavy body mediums can be used to create texture in the ground before the oil paint is applied.

Don't glare at me

The lighting conditions under which most paintings are exhibited are very rarely ideal. To increase the appeal of a painting the surface texture should be considered. **If you want your paintings to show at their best, and be the buyer's choice, you must take texture and varnish into account.**

A rough texture tends to scatter light better than a smooth surface, so the viewer will see the values and colors more clearly. On the other hand, a smooth surface texture tends to promote areas of glare under anything but the best lighting conditions. (The dark values are also especially susceptible to glare.)

A very flat glossy surface can turn people off what may otherwise be a great painting.

The scale or size of a painting can also impress the viewer in the following ways. **Larger paintings simply have more impact.**

GALLERY WALL

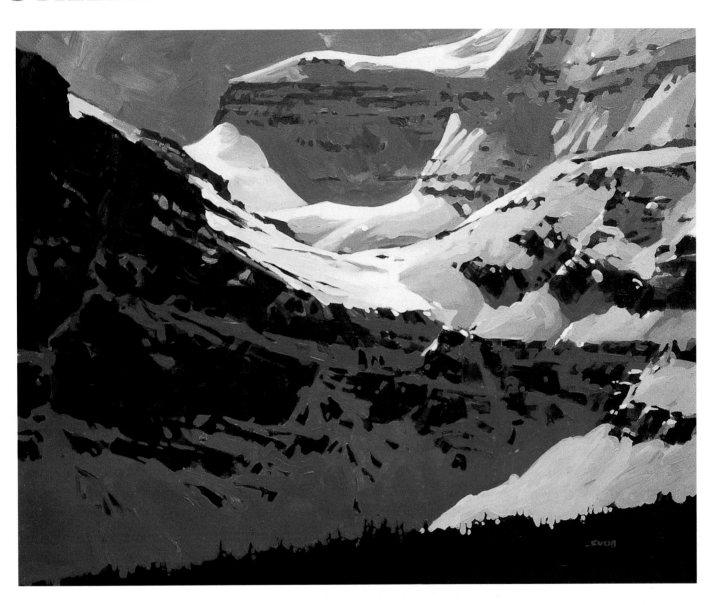

They are harder to ignore. However, it is even more difficult to control glare and reflections in larger paintings. I do it by simply **adding more texture to the ground as size increases**.

Another finishing problem peculiar to oil paint is the way oil paint tends to dry to a flat finish. The result is a loss of color intensity, and tonal value. To bring the color and value back to where it was when the paint was just applied and still wet, a **varnishing agent** of some sort is necessary.

How to varnish so the painting looks fantastic

The preferred varnishing method is as follows:

I recommend damar varnish because it provides a durable and glossy surface finish to oil paintings.

Before you attempt to varnish them, oil

Yoho Blue, 22 x 28" (56 x 71cm), acrylic on canvas

Definitely the coldest painting I have ever done. This one gave me the shivers it is so cold. In winter in the Canadian Rockies the sun is quite low in the sky. Even at noon the light seems to just caress the snow on the mountains and, as a result, you can see the sensuous curves and forms of the snow wrapping around the rocks and sides of the peaks.

paintings should be allowed to oxidize (dry) for six months. The wait will help prevent unnecessary cracking. When the time is up, varnish can be applied using a brush or spray to achieve the desired gloss. Varnish can be chemically removed from your painting at a later date if necessary, when it has yellowed and become dirty from hanging in the Guggenheim. The oil paint film will not be affected by varnish removal. Museum types love it when you practice the correct methodology.

Many oil painters do not want to wait six months before varnishing so they use alternate means. The techniques used to speed drying and enhance surface finish are numerous.

Drying medium works to speed drying and provides a glossy, vibrant surface finish. A small amount is mixed with the oil paint as it is applied.

Other artists will use a medium that contains some damar varnish to mix with their oil paint as they proceed.

Retouch varnish, which is a mixture of turpentine and a very small amount of damar varnish, is also used. Retouch varnish is usually sprayed onto a partially dry oil painting to bring the color and tonal value back to where it was when the paint was wet. Once applied, retouch varnish quickly dries back to a flat finish.

All these methods of achieving a surface gloss have their positives and their negatives concerning permanence, which requires more discussion than this book is intended to provide.

The method I use at present to solve the problem of surface finish and speed drying is relatively new. I use artist quality alkyd that can be purchased in different consistencies, thin to thick. I use this as my medium. I buy the thickest and thin it as necessary with mineral spirits. When I am painting on location I add a small amount of drying medium to speed things up even more. Thin passages quickly dry tacky. Thicker applications that contain at least some alkyd may take a day or two.

Whatever method you use to solve the drying and surface finish problem, remember oil paintings should still be varnished after six months.

Snowy Road, 24 x 30" (61 x 76cm), oil on canvas
The inspiration for this painting came from a watercolor sketch I made some 15 years before.

The painting was started on a black ground that still shows through in many small, scattered areas of the painting. The procedure was to paint in the highest key or lightest value shapes first. The mid-tone and more vibrant colors were painted after that. The painting was finished in one sitting so that I could take advantage of the wet oil paint to blend and soften edges where I felt it was necessary.

INTO THE POT

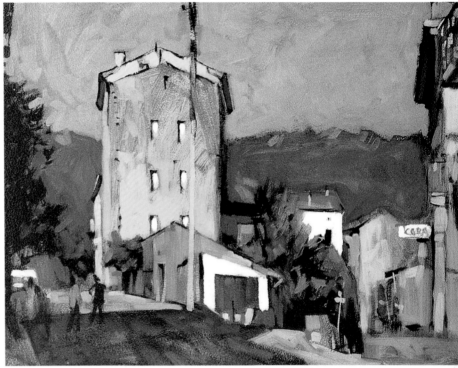

French Village, 12 x 16" (31 x 41cm), oil on panel

Many years ago Nancy and I spent a glorious summer bicycling through Europe. I did not paint on that trip but instead gathered reference material. We actually kept getting rid of things to make the bikes lighter. As a result, by the end of the trip we had plenty of reference material, but we were down to shorts, shirt and a toothbrush. The pace of cycling allowed time to see vastly more than you would from a train or a car.

The procedure for painting began with a black gesso drawing, which was then covered with a glaze of Transparent Earth Brown. When this had dried sufficiently, a translucent Cobalt Blue with Titanium White was applied to the sky.

Working forward, I finished the distant mountains, and the middle distance buildings using warm intense color.

The foreground building and shadow area were kept a little more subdued so they did not draw the eye away from the focal point.

The red roof and green door were painted last, using contrasting color to create a strong focal point.

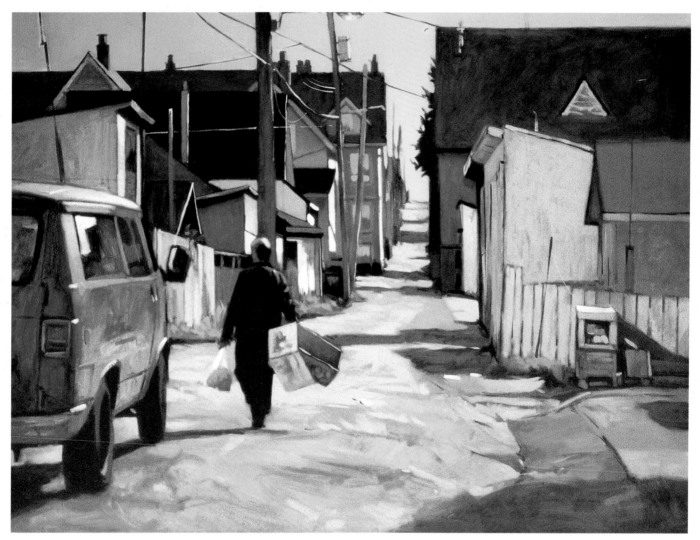

Back From The Market, 30 x 40" (76 x 102cm), oil on canvas

Before I painted this I moved the figure carrying the boxes around a couple of times. Now I see the figure should have been to the right.

This was a ground breaking painting for me. For the first time several techniques were used on a canvas with a positive result. A washy granular look on the road and some of the buildings was one.

The high key warm sky was also a first. Things will happen in your paintings almost serendipitously that you will find appealing.

Try to remember how they happened and make use of these new techniques when the opportunity arises in later work.

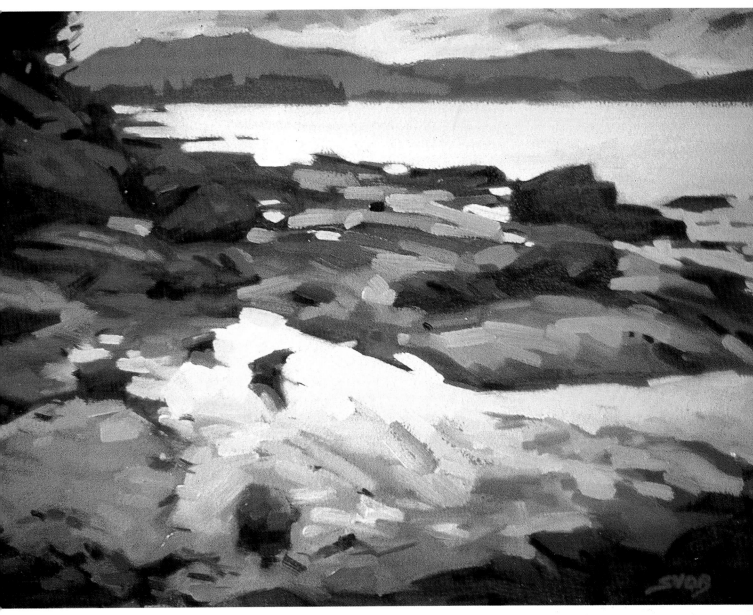

Gabriola Beach,
16 x 20" (41 x 51cm), oil canvas
The tidal patterns are constantly changing as the water ebbs and flows, forming ever-changing patterns along the ocean's edge. This short stretch of beach and ocean has yielded abundant reference material for many paintings.

This one was begun on a deep red toned surface. All subsequent paint applications were cooler and more opaque.

If you want your paintings to show at their best, and be the buyer's choice, you must take texture and varnish into account.

The Sardonic Mountains,
12 x 16" (31 x 41cm), oil on panel

You will not find these mountains on any map. The name is fictitious. The area of orange in the lower half of the painting shows granulation as a result of the ground.

Some oil paint pigments exhibit this quality when the paint is applied in thin glazes and the work is allowed to dry slowly. It is a property of some watercolor pigment as well. If you are observant and creative you may think of other places to use this.

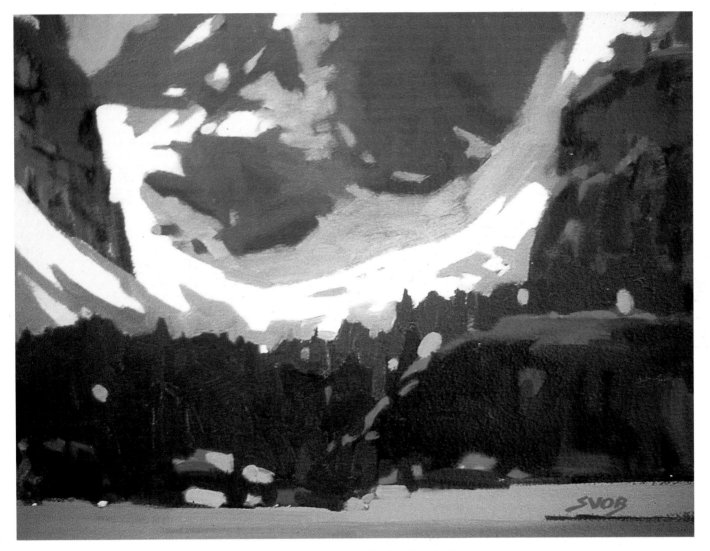

Near The Stepping Stones, 9 x 12" (23 x 31cm), oil on panel

The lower area of this painting started out as a lake but the water did not seem to help the composition. A cool green mixture was used to cover the lake, and my intention was to try to paint the water over this. The effect of this simple shape seemed to improve the painting so I stopped there. The lake is now grass.

The lesson learned is to stop while you are ahead, which is not always an easy thing to do.

EXERCISE

Boosting sales appeal with texture

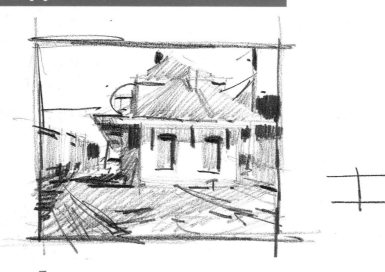

1 Make the tonal value thumbnail

The painting begins with the thumbnail again. The creativity is really in this early stage. Once you've done the thumbnail your creative side will make sure the technical worker side stays on track. Of course, your technical side is allowed some small creative sentiment, but no wholesale creative outbursts.

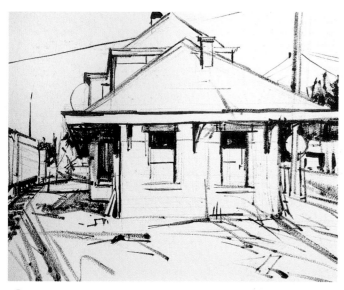

2 Do your gesso outline

Make an outline with black gesso. The reasons for using black gesso are twofold. First, it dries very quickly. Second, the surface texture is the same as the gessoed canvas. The black gesso takes the oil paint the same way as the white gesso. Black gesso is also thick enough to allow a dry brush texture that I have found useful in places.

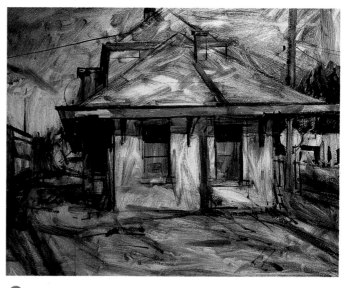

3 Apply thin, transparent glazes

What is going on here? You should be freely brushing on thin applications of transparent pigments and allowing them to mix together to some extent. Keep the overall color relationship warm. Introduce some cooler pigments to give the painting a cool-to-warm play. Try to work with this play of color as much as possible as the painting develops. For this transparent stage use thinner liberally.

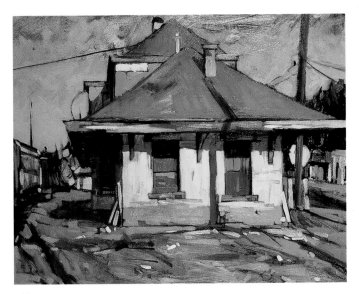

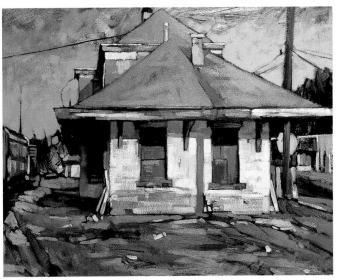

4 Enhance the shapes and tonal values

Here the forms and values should be given more of their own identity. Paint the roof a deeper brown to set it off from the sky. Apply a darker glaze to the shadow area on the left. Work your way around the painting, developing the basic value and color relationships further without adding too much finishing detail.

5 Bring in the cools

Paint a mixture of cooler, translucent color onto the roof to create more separation from the sky. To the right of the train station make the sky lighter in tonal value and a richer yellow. Work in some of the lightest values on the building and the other areas to create points of interest and to establish a full tonal value range.

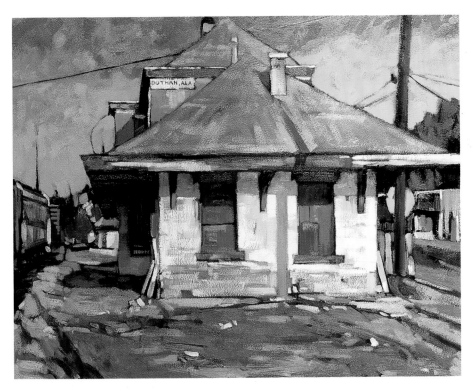

SELF EVALUATION

How did you handle this exercise?

What did you find most difficult?

What did you find easy?

Do you understand now how important texture is to a painting's appeal, and do you know how to do it?

6 Finish off

To finish "Southern Station", allow it to dry overnight. When the paint has set sufficiently to allow dry brushing over the top, get back to it. Add the cool blue sky with broken color to soften the edge where it meets the warmer area of the sky. Use more dry brush in numerous other areas to give the subject and painting a textured, weathered look.

The character of this old abandoned train station demands some dry brush treatment. Each subject or painting has its own challenges. Each provides its own rewards.

CHAPTER 9

CREATING A VISUAL FEAST THAT

Go looking for inspiration. Find subjects that speak so strongly to you that you can't wait to paint them. Immerse yourself in the energy of the location, and then it won't matter how you bring it home alive — sketches, studies or photos — just as long as your passion is stirred. Put that in your paintings and just see what happens to your sales.

Painting on location is one romantic notion about being an artist that I refuse to let go of. The warm sun on your back, a cool breeze in your face and maybe your favorite beverage by your side. The landscape of your dreams unfolds in front of you. This is the way it should be for all landscape painters.

Working outdoors on location is a great source of **inspiration** for many artists, including this one. For others, painting outside is nothing but a constant battle with the elements, and it is to be avoided like the plague. There is a notion in the *plein air*, on-location camp that all real artwork is created when working from life. The other camp believes anything worthwhile comes out of a studio where the elements, that is, the weather, lighting or measurement of your subject can be controlled. There is no reason why you cannot make use of the best working methods inherent in both camps.

I spend a fair bit of time traveling in search of **new material**. This may be a 15-minute walk to my local beach with my camera, or a two-week, on-location painting trip. Although many of these excursions yield meager tangible results in the form of finished paintings the time is by no means wasted. **The journey you begin when you decide to become an artist often means time is**

spent making mistakes or seemingly wasting time. The experience of the place or the practice of a new technique is never a waste of time. It is part of growing as an artist. If you keep seeking, eventually you will find.

If there is a place you find inspirational or irresistible, photograph there, sketch there and paint there. Even if at first blush you cannot capture the energy of the place in your work, eventually the inspiration will find its way into your paintings. **Patience and practice will help you distill the source of visual inspiration into your works.** Others will find it there as well and be drawn to your art. Working in a studio setting from a slide projected onto a screen lacks such inspiration but it does offer more control and time.

The time factor

One of the important lessons learned by painting on location is the result of being **constrained by time**. When you paint outdoors on a sunny day, the light and shadow pattern is changing constantly. I allow myself about 60 minutes, or 90 minutes tops, to work on a painting. There is no point in looking at your subject matter after this amount of time, it will only confuse the issue.

The result of being limited by time is the demand to **simplify** so you can get it all

down before the light changes. **You learn to group tonal values and shapes, to simplify edges, and to limit your choices.** There is just no time to nit-pick and second-guess yourself. You learn to make bigger and broader decisions about what you are trying to say in your paintings. This practice is invaluable to the **growth** of your ability in design and composition.

The same thing happens when you work from a model. The model is going to move. Of course, certain things can be done to stretch the amount of time you have for working from life. You can return the next day at the same time to continue working on the same painting. Or you can book the model to do several sittings. In practice I rarely have the opportunity to return to the same location the next day and if I do it is invariably cloudy or rainy and the light is completely different. Getting the painting done in that one-hour session is a better idea. In order to complete a sketch or painting in this amount of time **keep the size small and your technique simple.** If you manage to execute a good painting in that hour (and you will with practice) you can go back to the studio and use it as reference, along with photos and/or sketches, for a larger version. Invariably you will find the smaller painting will be simpler, fresher and more spontaneous than the larger version.

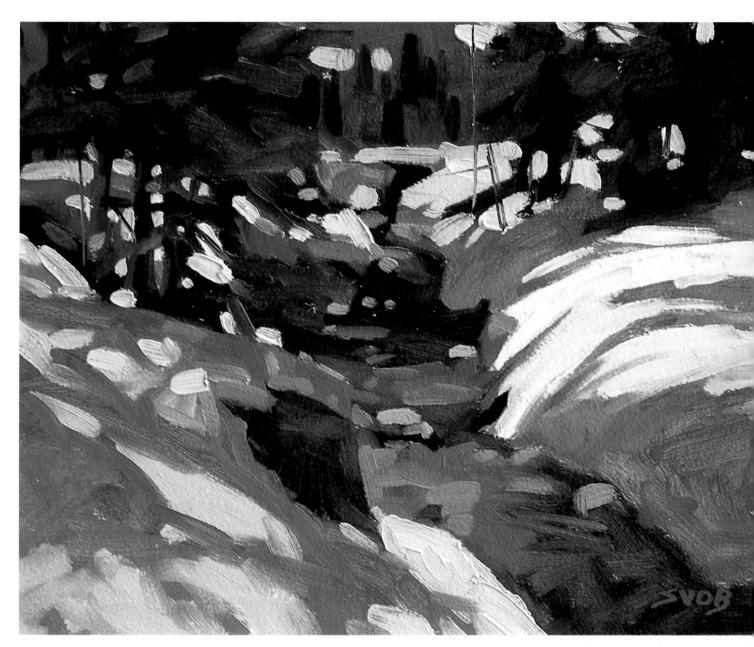

Dappled Light, 9 x 12" (23 x 31cm), oil on panel
The deep snow-covered banks frame the stream that leads into the distance. The design is quite simple, and the warm light on the trees and rocks plays quite well against the deeper, cooler shadows.

THE PASSION THAT SHOWS THROUGH

An on-site sketch turned into a major painting

Start at the scene — finish in the studio

Another method I use for on-location work is to block in the large value shapes and colors on a larger size canvas or board. I then head back to finish it in the studio. In this case I will take a photograph, usually a slide to help with values, drawing and detail. A color slide is a far cry from the real thing but it is the second best choice. **Do not be shy about taking photographs** and using them as reference because of some silly, artistic hang-up about copying from photographs stifling your creative side. Artists have used photographs as reference (and often denied doing so) since the invention of photography. **Virtually all professional artists use photographic reference as part of their painting process.** The *caveat* is to be careful not to let the photo become your master. Remember you are in charge.

If you are from the camp that is going to paint from photographic reference only, make sure your reference is the best it can be. From my perspective the poorest art possible is invariably a badly painted copy of a very bad photograph. Learn how to use a camera. The new digital cameras are very simple to use and allow you to crop or otherwise alter the image before you even think about painting.

Your reference material is a big part of your vision and inspiration as an artist. It is where the artist's ideas originate. Get the best reference you can to work from whether that is photography, sketching, a still life, a model or on-location. In the end your paintings will reflect the quality of your reference material.

In short, as a wise old artist once said, all things being equal, the better the reference, the better the painting.

Shannon's Cascade — sketch, 12 x 16" (31 x 41cm), oil on canvas
A brief stop on a trip into the mountains yielded material for about six or seven paintings. The sketch shown here was later developed into a larger version. When I travel, even on short trips, I take my camera. If I see something interesting I take a photograph for painting reference.

Try to gather your reference material early and later in the day when the light conditions are the best.

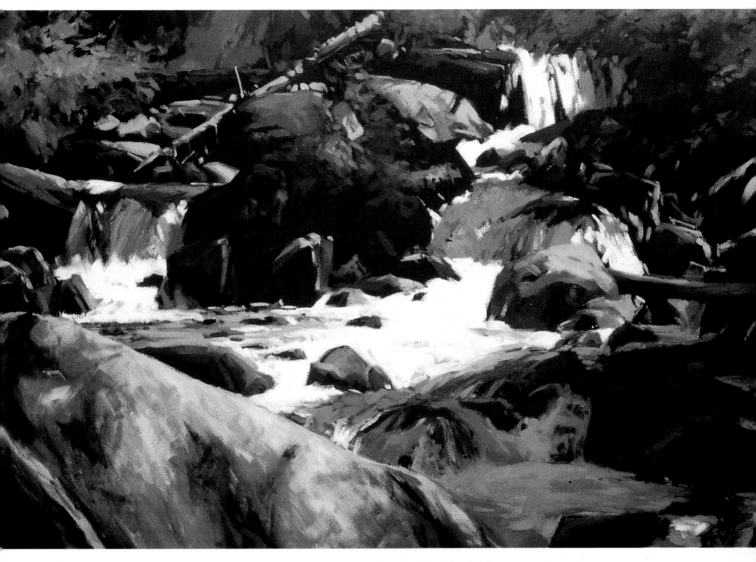

Shannon Cascade — studio painting, 24 x 36" (61 x 91cm), oil on canvas
The larger version of a sketch often lacks the spontaneous charm of the original. In this case the studio painting has some qualities that are more appealing than the original sketch. There is a softer, subtle quality to the edges in this larger version.

What do you think?

What differences can you see in the two versions?

Which one do you prefer, and why?

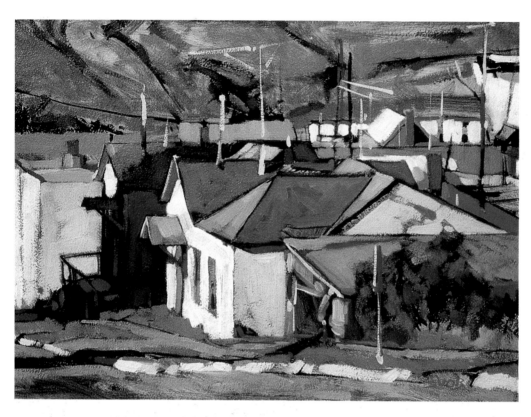

Roofs, 12 x 16" (31 x 41cm), oil on panel

The early morning light striking these old homes caught my eye. I find the light early in the day is much better for capturing color, tonal value and shape. In the northern latitudes where I live, it means getting out there very early in the summer months. By 8:00 a.m. the best light is gone. In the middle of the day the light is too strong to judge tonal values and color correctly. Later in the day after 7:00 p.m. there is another period of good light.

Try to gather your reference material early and later in the day when the light conditions are the best.

Turkey Talk, 12 x 16" (31 x 41cm), oil on panel

Inspiration can come from just about any source. The challenge provided by different subject matter is one of the things I find most enjoyable about painting. It forces an artist to change their approach or outlook. This in turn may provide a new direction or fresh eye on the usual subjects.

Shell Seekers, 18 x 24" (46 x 61cm), oil on canvas
This is one of my earlier oils. Two of the children searching out hidden treasures in the tide pools and under rocks on the seashore are mine. Gathering reference from which to work has meant that my family appears in numerous paintings. Children, with their inherent curiosity, fit in well with the curiosity of the artist.

HOW TO PAINT OILS SO THEY DRY QUICKLY

One of the problems with using oil paint for location work is that it has a slow drying time. This is what I do to speed things up: I use any of the common brands of alkyd. (Alkyd can be purchased in differing consistencies. I use the thickest and thin this as necessary with mineral spirits.) In combination with the alkyd, I use a small amount of drying medium in the thinner, earlier passages which may be painted over with thicker layers.

The thin passages dry to a tacky surface within an hour or two. Thicker passages that contain at least some alkyd may take 24 hours. Alkyd also has the advantage of providing a gloss finish that keeps the color vibrant and deep.

Even if at first blush you cannot capture the energy of the place in your work, eventually the inspiration will find its way into your paintings.

Tribune Bay, **12 x 16" (31 x 41cm), oil on panel**
The rocky shore pattern drew me to paint this coastal scene. Some of the rocks were covered with brilliant green seaweed. The wispy tree shapes in the upper left provide a surprise vertical shape. Note the gradation in the sky as it changes from warm to cool. This type of gradation helps to make large flat shapes more interesting. There is gradation in the mountains and a few other places too. **See if you can identify them.**

Waiting Biker,
12 x 16" (31 x 41cm), oil on panel

After teaching a workshop on Saltspring Island I rushed off to catch the ferry back to the mainland. Upon arrival at the terminal I was greeted with the news that the ferry had been postponed. Seeing the glass "half full", I noticed a great number of involuntary models waiting around the terminal, and the afternoon spent at the terminal turned out to be a prolific one. At least a dozen paintings resulted from my sketches and photos.

Develop the attitude to always be looking for that next piece of inspiration because you never know where it will pop up. Without a positive attitude inspiration will slide by unnoticed.

MY STUDIO SET-UP

The studio is the next best thing to being there. A slide projected onto a screen is quite often the basic reference for my paintings. The studio is kept quite dark to get the best quality projected image possible. Separate lights are projected onto the painting surface and my palette.

I have tried many different studio set-ups over the years. This is the latest and it will probably evolve along with my artistic outlook and endeavors.

WORK SMALL, LEARN BIG

Developing your options on site

A good way to get your creative juices going on a certain subject or location is to draw several small sketches from the same spot. Here you will see how I made three small panel paintings on a single 16 x 24" (41 x 61cm) gessoed panel that I divided using a strip of masking tape. I had started on the fourth idea when hunger intervened, as it often does in my case.

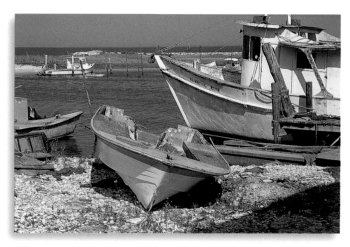

1 How many paintings can you see in this photograph of the scene? *This spot at Eastport offered several opportunities.*

The point of a painting exercise such as this is to come up with a new idea or learn something. If you keep your eyes and your mind open to new possibilities you will find them.

2 **Simple Division**
I divided a gessoed panel into four and painted each a different preliminary color. The top left is Transparent Earth Red, below that Cadmium Red, top right is Dioxazine Violet, the last color is Cobalt Blue. The reason for starting each on a different color is the experimental factor. Every time I do this I try to come up with a different creative image and/or a new technique. When I begin I am not sure exactly what the result will be, just that I will get a different result than if I always use the same approach.

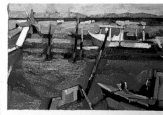

3 **Three done, one on the way**
Here's how my panel looked when "paintus interruptus" hunger pangs struck.

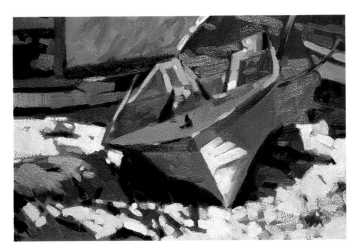

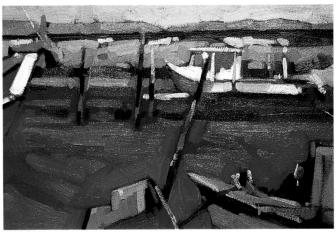

4 An abstract/realist tug of war

As I paint each image I try to make opposite choices to the ones I might normally make in some parts of the painting. Here, for example, I left the hull of the large boat red instead of light violet as it appears in the reference photo.

In other places I went with a more realistic look such as the very light beach, or the shadow on the boat in the foreground. Part of what happens is a tug of war between wanting to paint in a realistic way or making it more abstract or impressionist. Things go both ways in this picture.

5 Experimental composition

In this painting I tried to present a different composition than I would usually do. Points of contrast were established around the outside of the design. There is very little in the middle of the painting to draw the eye. The small boat in the upper right keeps everything in perspective and becomes the center of interest. Except for the sky the colors are close to the reference.

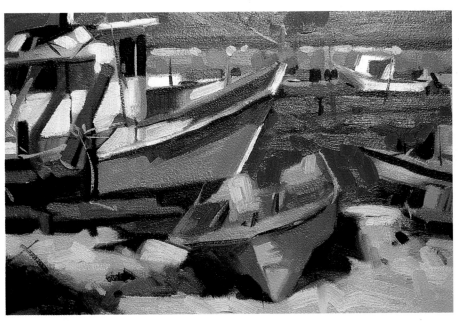

6 Technique and color ploys

Here the subject was painted with only minor changes. The biggest change is the warming of the entire color range. In this version and the previous version the paint was applied in thicker layers, and I allowed the brushwork to show. Brushstrokes can often help harmonize a painting.

In all three versions I tried to establish what I consider to be good design. A focal point or center of interest, a wide range of value for visual impact, and a color surprise or intensity of color appears in each painting. If you let good design dominate your paintings they will speak to viewers — and buyers.

SELF EVALUATION

What do you do to actively stimulate your creativity?

Do you work only on location?

Do you work only in the studio?

Do you only stick to one technique, style, color scheme?

Do you attempt different subjects?

What are you going to do about that?

GALLERY

Let's see what makes these paintings so special.

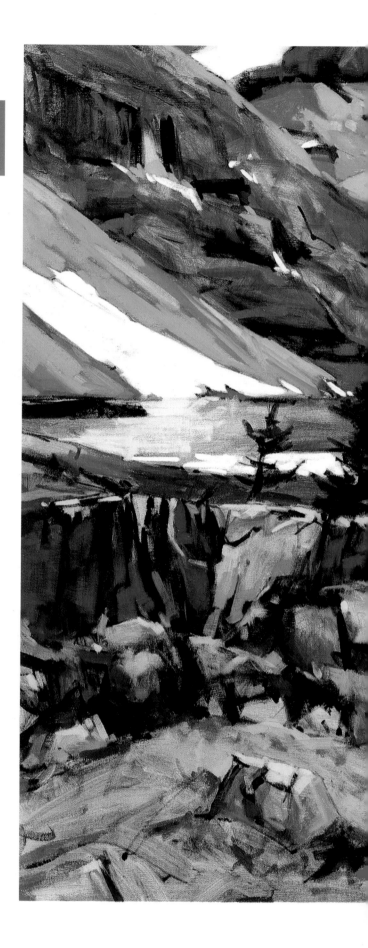

Lake Oesa, 30 x 40" (76 x 102cm), oil on canvas
The small trees and rocks in the foreground help to add depth and scale to this version of Lake Oesa.

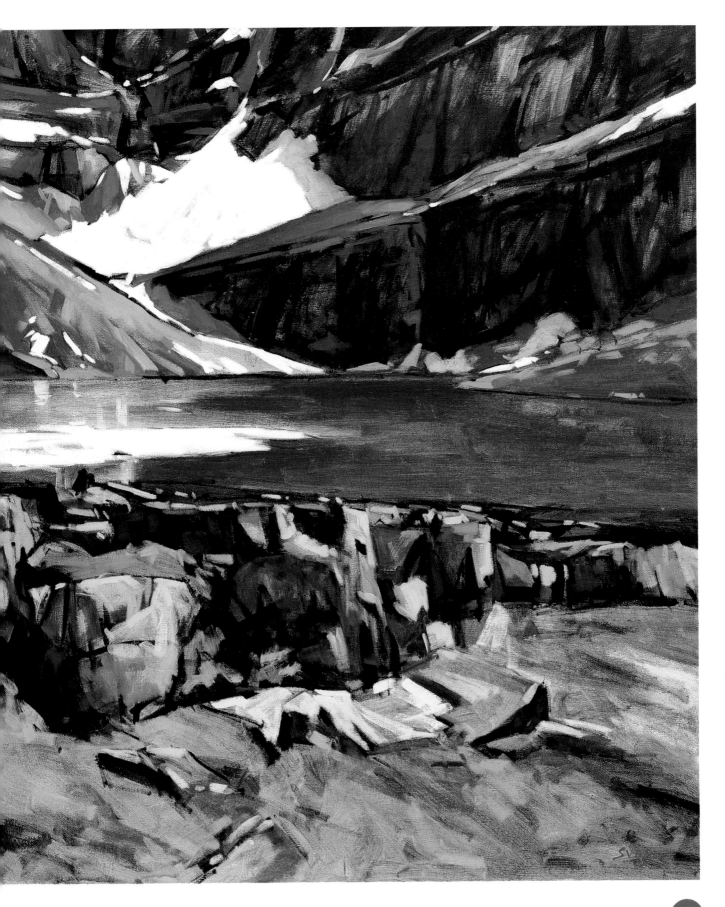

The Red Box, 12 x 16" (31 x 41cm), oil on panel

Line plays a greater role in this painting than usual. The power lines, pole lines, shadow lines, roof lines, and so on, combine to give it a visual harmony of thin shapes. This contrasts with the larger more angular shapes.

The play of shapes was not planned as such. It was there and all I did was allow it to dominate. In another situation, or maybe on another day, I would have emphasized some other graphic element.

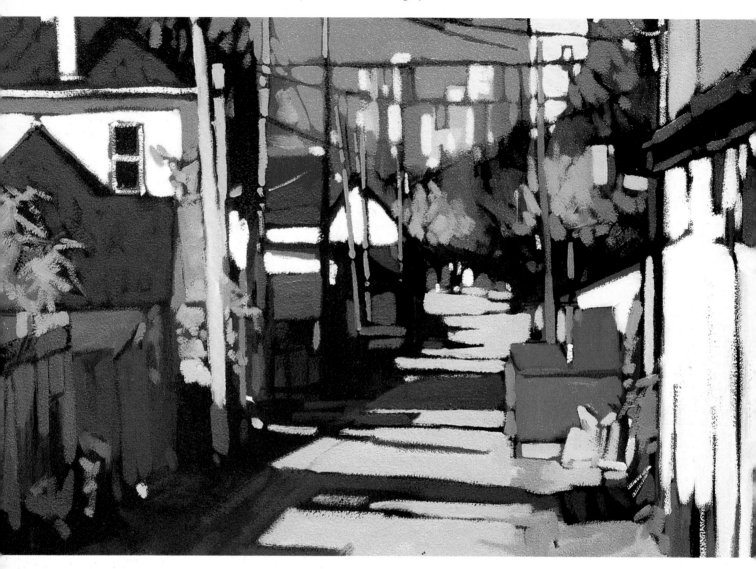

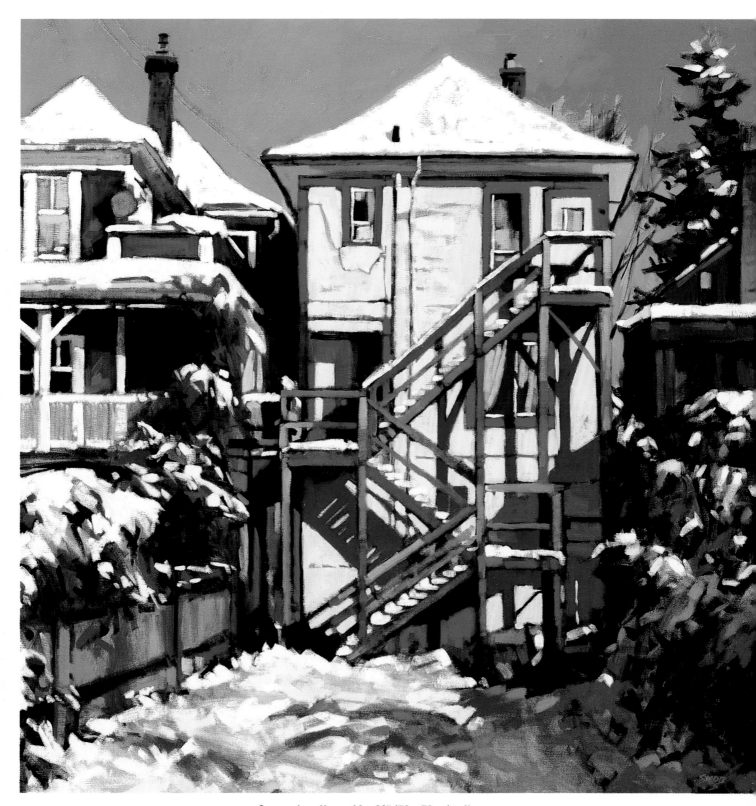

Snowy Landings, 30 x 30" (76 x 76cm), oil on canvas
There is something about fresh snow that gives me the feeling of renewal. It also helps to visually harmonize a scene by spreading a colòr (white snow) blanket over everything.

Alley Shadows,
12 x 16" (31 x 41cm),
oil on panel

*Pathways have been a common
theme in painting for hundreds
of years. Alleys, roads, rivers,
a forest path, all invite the
viewer to explore. Scattered
along the path are visual
points of contrast to pique
the viewer's curiosity.*

This One is Mine, 30 x 24". (76 x 61cm) oil
Sienna my daughter was about eight years old when this painting was done. The farm we were at had several dozen cats and kittens scurrying about. When she finally caught one she did not want to let it go. I captured the moment with my camera and painted it several years later. This is one of those paintings I just could not part with.

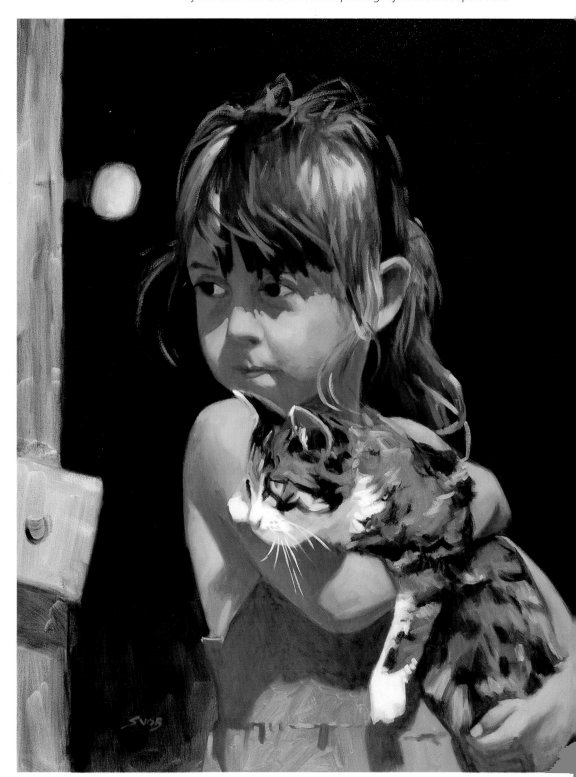

Just Have Fun,
24 x 36" (61 x 91cm),
oil on canvas

Soccer is popular in our area. The children get to burn off all that extra energy they seem to have, while having a great time. In this scene, everything except the young girls and their coach, was eliminated to bring focus to the figures. The highlights on the hair and the numbers on the uniforms provide points of interest. Transparent glazes of Dioxazine Violet and Ultramarine Blue give way to Viridian and Cadmium Yellow on the grass. The darks on the figures were brushed in with Ivory Black and Transparent Earth Brown. For the highlights on the hair I used a bit of Cadmium Yellow and Titanium White. Getting the values right was the key to achieving that sunny day feeling. Canvas was the choice here because texture was not going to be important to this image.

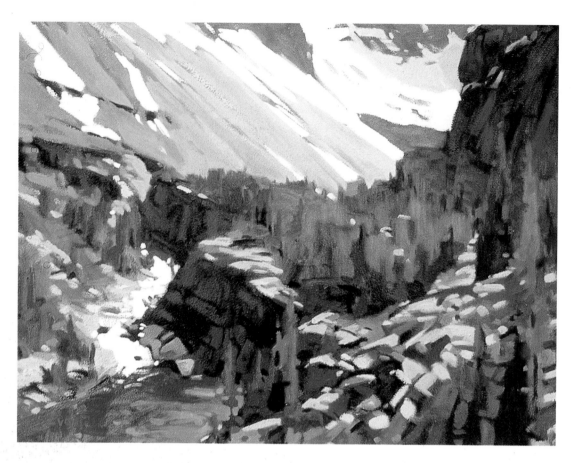

The Stepping Stones,
20 x 24" (51 x 61cm),
oil on canvas

The stepping stones are to the left of the small blue lake enabling hikers to cross a watery part of the trail to Lake Oesa. This design has strong diagonal elements.

Charlotte Estuary,
12 x 16" (31 x 41cm),
oil on panel

The deep, dark reflections in the river pools were the inspiration for this painting. It took three or four tries to get the result you see here.

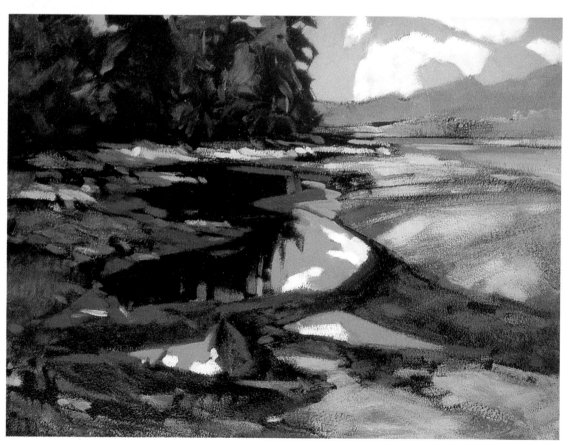

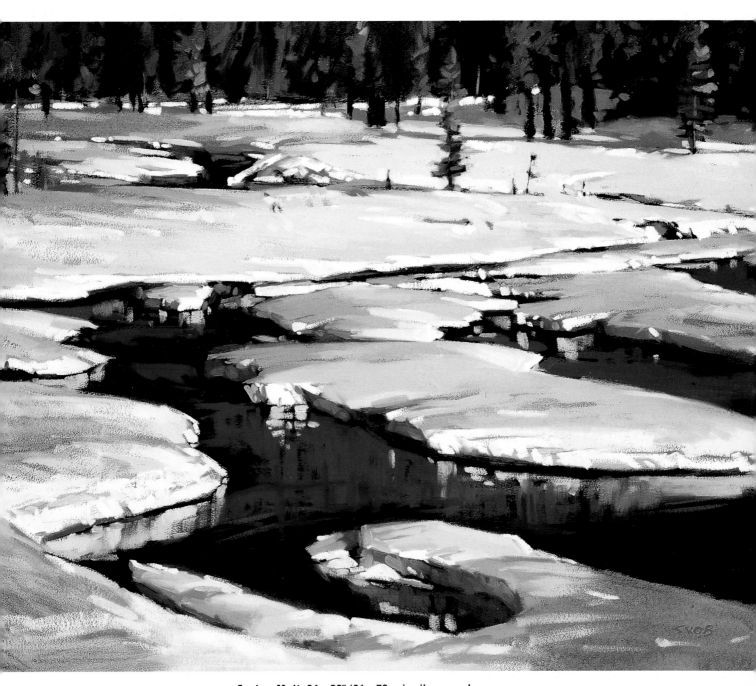

Spring Melt, **24 x 30" (61 x 76cm), oil on panel**
This stream has many paths. The alternating light snow shapes and dark reflecting pools create an interesting pattern that leads off into the distance. The trees serve as sentinels along the way.

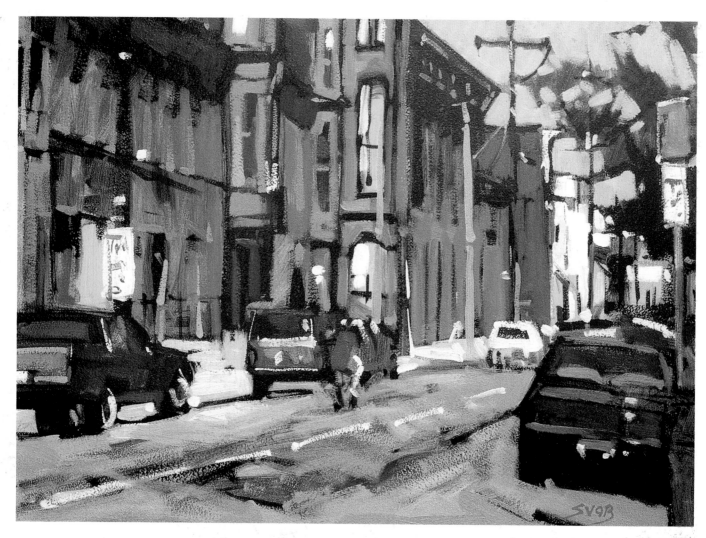

Easy Street,
12 x 16" (31 x 41cm),
oil on panel

The challenge of simplifying a street scene can seem daunting because there are usually so many different elements at play. The trick is to get your mind to see and judge the whole scene, not each element.

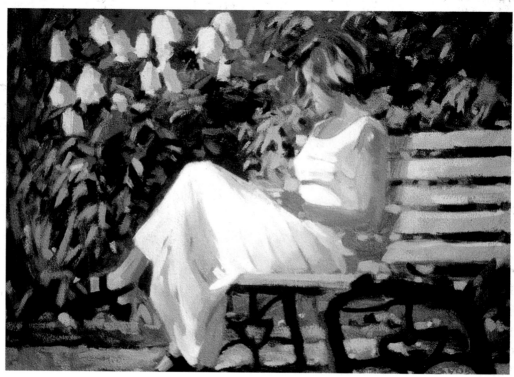

A Quiet Moment,
12 x 16" (31 x 41cm), oil

Aspen Pattern,
12 x 16" (31 x 41cm),
oil on panel

The aspen leaves had already started to turn, giving them this golden green color. Rarely do I try to capture the real life color relationship. In this case I felt it was warranted.

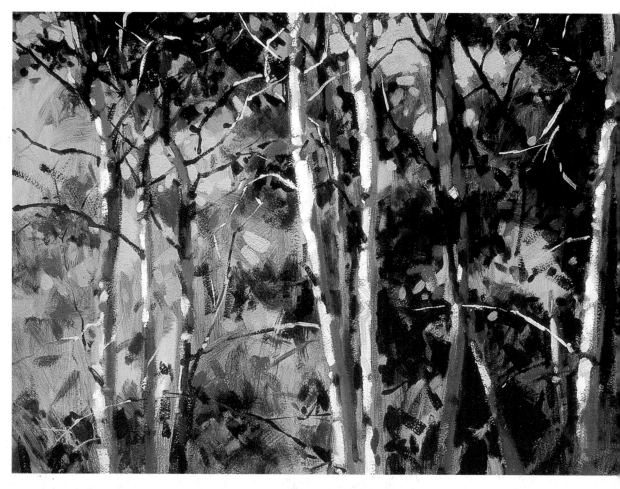

A Snowy Lane,
18 x 24" (46 x 61cm),
oil on canvas

Vancouver does not get much snow. So when 8 inches fell one night, I was out before the sun came up to capture the feeling on canvas.

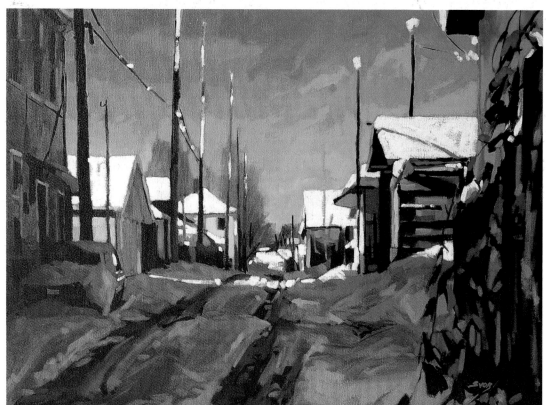

ABOUT THE ARTIST

Mike Svob lives in White Rock, British Columbia, Canada. He has been a full time artist since 1982. This 20-year career has allowed Mike to master watercolors, acrylics and oils. At the present time he is working almost exclusively in oils. He has completed over 45 exhibitions to date, and has produced over 22 large-scale murals throughout North America.

Mike studied at the University of Western Ontario. He is a past President of the Federation of Canadian Artists and is also a senior member (SFCA) of this society. As an award-winning artist and a leading teacher and workshop instructor, Mike strongly believes that sharing knowledge among fellow artists and art students provides only positive results for all.

His paintings are held in many private and corporate collections throughout the world.

His work has been featured in *International Artist* magazine and in the book *Design & Composition Secrets of Professional Artists*, published by *International Artist*.

Mike Svob can be contacted by email at artfriend@axion.net

PAINT RED HOT LANDSCAPES THAT SELL!

*A sure-fire way to stop boring and start
selling everything you paint in oils*

by MIKE SVOB

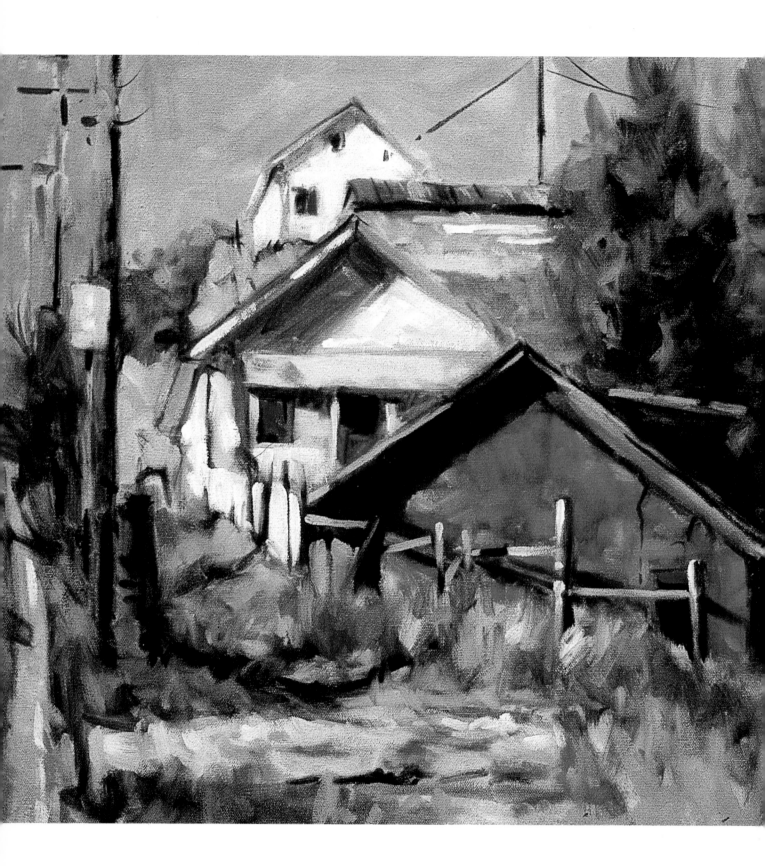